Unpacking My Library

Unpacking My Library: Writers and Their Books

Edited by Leah Price

Yale University Press
New Haven and London

yalebooks.com

Thanks are offered to the following people: Katherine Boller,
Tom Buhler, Alison MacKeen, Abigail Major, Jo Steffens, and
Anna Winger.

Michelle Komie, Senior Editor, Yale University Press
Michael Bierut and Yve Ludwig, Pentagram Design
Set in Mercury Text and Caecilia
Printed in China by Regent Publishing Services Limited

Photography by Gabrielle Reed and Christian Lazen-Bernardt;
and Michael K. Mills.

Library of Congress Cataloging-in-Publication Data

Unpacking my library : writers and their books /
edited by Leah Price.
 p. cm.
ISBN 978-0-300-17092-4 (cloth : alk. paper) 1. Authors, American—
Books and reading. 2. Authors—Books and reading. I. Price, Leah.
II. Title: Writers and their books.
Z1039.A87U56 2011
028'.9—dc23
 2011022679

A catalogue record for this book is available from the
British Library.

This paper meets the requirements of ansi/niso z39.48-1992
(Permanence of Paper).

10 9 8 7 6 5 4 3 2 1

Introduction

As a teenaged babysitter, I went straight for the books. No sooner did the door close behind the spruced-up parents than I was on the prowl: the bedside table for erotica, the kitchen counter for cookbooks, the toilet top for magazines, and finally the official living room shelves. Only then did I scan the refrigerator. The French gastronome Brillat-Savarin would have approved: he began his *Physiology of Taste* (1826) by declaring, "Tell me what you eat and I will tell you what you are."

You are also what you read—or, perhaps, what you own. In my college dorm, a volume of Sartre was spread-eagled across the futon when I expected callers. We display books that we'll never crack; we hide books that we thumb to death. Few households shelve *Playboy* next to Plath. Junot Díaz lays his soul on the line when he declares, "I've never liked the idea of a hidden book. It means no one will ever randomly pick it up and have a conversation with you about it."

To expose a bookshelf is to compose a self. Buzz Spector's 1994 installation *Unpacking My Library* consisted of all the books in the artist's library, arranged in order of the height of spine, from tallest to shortest, on a single shelf in a room large enough to hold them. Shortly after the 2008 election, a bookstore in New York set out fifty-odd books to which Barack Obama had alluded in memoirs, speeches, and interviews. The resulting table revealed more about the president-elect than did any number of other bookstores that displayed books by and about him.

A self without a shelf remains cryptic; a home without books naked. The dollhouse given to Queen Mary in 1924 contained Lilliputian versions of the *Times* for January 1, as well as *Who's Who, Whitaker's Almanac,* and a railway timetable. The *Times* published several thousand copies to distribute to Mary's young subjects, with one difference: in response to mothers' anxieties that the one-inch-to-the-foot scale might strain children's eyes, the mass-produced model doubled the size.

In keeping with tiny toilets that flushed, Queen Mary's library was, so to speak, anatomically correct: its pages could be opened, turned, even read. Many life-sized books are less functional.

Any user of the vast virtual remainder table that is Google Books knows that titles are divided into "bookshelves." What they may not know is that in Google's Cambridge office, one wall is occupied by a different kind of bookshelf. A dozen flat strips of plywood are fixed to the wall at right angles to equally flat vertical strips of paper, each bearing the title of a book. These strips were once the spines of books; the volumes from which they were sliced have been disbound for scanning. Like taxidermists' trophies, the wall decor attests a successful slaughter. A cluster of yellow spines ripped from the "For Dummies" series reminds viewers that dummy spines have a long history.

In the early 1830s, Thomas Hood designed a set of dummy spines for a library staircase in the Duke of Devonshire's grand country house at Chatsworth, supplementing traditional fake-book titles like "Plain Dealings" and "Essays on Wood" with puns like "Pygmalion. By Lord Bacon." A few decades later, Charles Dickens lined his own study with dummy spines, for which he composed titles like "History of a Short Chancery Suit" (in twenty-one volumes) and "Cat's Lives" (in nine).

Our twentieth-century term "coffee-table book" inherits the scornful overtones of its predecessor, "furniture book." An 1859 article of that title compared bibliophiles who cared more about bindings than about words to lovers who "think more of the jewels of one's mistress than of her native charms." A millennium and a half before print, Seneca had already criticized "those who displayed scrolls with decorated knobs and colored labels rather than reading them": "How can you excuse the man who buys bookcases of expensive wood.... It is in the homes of the idlest men that you find the biggest libraries."

This translation takes some liberties, of course: what we think of as the traditional bookshelf is in fact younger than Gutenberg. Until a few centuries ago, books were shelved every which way *except* straight up and spine outward: laid flat, or turned fore-edge out, or placed on bookwheels that rotated multiple volumes into the reader's reach like cars on a Ferris wheel. Spines were

rarely even labeled, for books were not expected to be shelved with the back visible. As the engineer Henry Petroski puts it, "The vertical book on a horizontal shelf is not a law of nature." Today, however, bookshelves are among the most ubiquitous of mass-produced goods: Ikea alone has manufactured twenty-eight million Billy bookcases.

Books know their place: some pose on the shelf, others skulk beneath the bed. In 1747, the Earl of Chesterfield wrote to his son:

> *I knew a gentleman, who was so good a manager of his time, that he would not even lose that small portion of it, which the calls of nature obliged him to pass in the necessary-house; but gradually went through all the Latin poets, in those moments. He bought, for example, a common edition of Horace, of which he tore off gradually a couple of pages, carried them with him to that necessary place, read them first, and then sent them down as a sacrifice to Cloacina: this was so much time fairly gained; and I recommend you to follow his example. It is better than only doing what you cannot help doing at those moments; and it will make any book, which you shall read in that manner, very present in your mind.*

Whether toilet, bed, bath, or beach, the reading that lodges most vividly in our memory is often what's done far from any bookshelf.

Nothing more superficial than a book about bookshelves. "Due attention to the inside of books, and due contempt for the outside," Lord Chesterfield pronounced in 1749, "is the proper relation between a man of sense and his books." A century later, an evangelical magazine contrasted the good child who "puts books into his head" with the lazy child whose books are "only on your shelves." Because books can be owned without being read and read without being owned, bookshelves reveal at once our most private selves and our most public personae. They can serve as a utilitarian tool or a theatrical prop. Gazing at the bookshelves of a novelist whose

writings lie dog-eared on my own bookcase, I feel as lucky as a restaurant-goer granted a peek at the chef's refrigerator. The Duke of Devonshire's library, in contrast, bore more resemblance to a Viking range littered with takeout cartons.

For centuries, portraitists posed sitters with a book; today, subway ads for ambulance chasers picture the lawyer against a backdrop of leather-bound law reviews. The Strand bookstore in New York sells books by the yard to set designers and interior decorators alike. The problem, as the Irish humorist Flann O'Brien explained in the 1940s, was that visitors taking a book down from the shelf might notice its suspiciously pristine condition. Enter O'Brien's "bookhandling" service for clients who liked the look of leather bindings but lacked the time or ability to read their contents themselves. If you joined his book club, O'Brien explained, "we do the choosing for you, and, when you get the book, it is *ready-rubbed*, i.e., subjected free of charge to our expert handlers," at a series of different price points:

Popular Handling—Each volume to be well and truly handled, four leaves in each to be dog-eared, and a tram ticket, cloak-room docket or other comparable article inserted in each as a forgotten book-mark.

Premier Handling—Each volume to be thoroughly handled, eight leaves in each to be dog-eared, a suitable passage in not less than 25 volumes to be underlined in red pencil, and a leaflet in French on the works of Victor Hugo to be inserted as a forgotten book-mark in each.

De Luxe Handling—Each volume to be mauled savagely, the spines of the smaller volumes to be damaged in a manner that will give the impression that they have been carried around in pockets, a passage in every volume to be underlined in red pencil with an exclamation or interrogation mark inserted in the margin opposite, an old Gate Theatre programme to be inserted in each volume as a forgotten book-mark (3 per cent dis-count if old Abbey

programmes are accepted), not less than 30 volumes to be treated with old coffee, tea, porter or whiskey stains, and not less than five volumes to be inscribed with forged signatures of the authors.

On the other side of the Atlantic, Thomas Masson took the World War I era coinage "camouflage" as inspiration for his own 1923 neologism, "bookaflage." Emily Post disapproved; her 1930 home decorating manual compared "filling your rooms with books you know you will never open" to "wearing a mask and a wig." Against this chorus of condemnation, it's refreshing to find Jonathan Lethem counter that although "people sometimes act as though owning books you haven't read constitutes a charade or pretense, for me, there's a lovely mystery and pregnancy about a book that hasn't given itself over to you yet." Yet, or never?

Like an exercise bike rusting in the basement, a book gathering dust testifies to good intentions. Ninety-two percent of American households contain a Bible; the average household, in fact, lays claim to three. Fewer than half of those respondents, however, can name the first book of the Old Testament. We shouldn't take this gap as a sign of cultural decline. Two centuries ago, a magazine already joked that

some gentlemen of a Bible Association lately calling upon an old woman to see if she had a bible, were severely reproved by a spirited reply. "Do you think, gentlemen, that I am a heathen, that you should ask me such a question?" Then addressing a little girl, she said, "Run and fetch the bible out of my drawer, that I may show it to the gentlemen." They declined giving her the trouble; but she insisted upon giving them ocular demonstration that she was no heathen. Accordingly the bible was brought, nicely covered; and on opening it, the old woman exclaimed, "Well, how glad I am that you have come; here are my spectacles that I have been looking for these three years, and didn't know where to find 'em."

We think of spectacles as a tool for reading books, but books can also be tools for storing spectacles.

Rebecca Goldstein reflects on "a time when we had some vases and candlesticks mixed in with the books, but I didn't like that at all. It seemed to me to qualify as what philosophers call a 'category mistake.'" Goldstein adds, "Kant tells us that a person can never be used as a means to an end, but must be viewed as an end in itself. This is one of the formulations of his famous categorical imperative. Well, that pretty much summarizes my attitude toward books. I would *never* use a book as a coaster or to prop up something else, any more than I'd use a person toward that end. Well, maybe a phone book, but not a book that was authored, into which some suffering writer—and all writers suffer—poured her heart and soul."

Will bookaflage survive the digital age? Amazon's release of the Kindle prompted the *New York Times* to predict that literary taste would go underground. No longer would strangers strike up conversations about the paperbacks poking out of their pockets, or deploy an author's name as a pickup line. Quoting a radio host who remembers that "when I was a teenager waiting in line for a film showing at the Museum of Modern Art and someone was carrying a book I loved, I would start to have fantasies about being best friends or lovers with that person," the article doesn't acknowledge that in an age when films are streamed onto the viewer's own laptop, Facebook allows us to scan our friends' virtual bookshelves. More sinister, marketers continue to add to their toolbox for tracking the eyes and thumbs of online readers, since the number of click-throughs determines the value of advertising placement. The Kobo e-reader tracks the number of books and pages a user has read, even down to pages per minute and the times in which a user most frequently read.

In the same month, *Vanity Fair* asked us to "pity the culture snob, as Kindles, iPods, and flash drives swallow up the visible markers of superior taste and intelligence." We needn't worry. Social networking sites like Shelfari and LibraryThing

allow us to pose and to pry as much as a piece of mahogany furniture ever did. When Jared Loughner went on a shooting spree in Arizona, his MySpace and YouTube pages were scanned for clues to his state of mind. It would be unfair to blame Loughner's paranoia on his reading list, since plenty of other disaffected male teenagers (and what teenager isn't disaffected?) have read or at least cited *Animal Farm, Brave New World, Mein Kampf,* and the *Communist Manifesto.* Less typical for his gender were the photographs of Loughner volunteering at a Tucson book festival, and the MySpace listing of "reading" as his favorite interest.

Far from making reader response invisible, then, the digital age may be taking us back to the Renaissance tradition of readers commenting in the margins of their friends' or employers' books and contributing homemade indexes to the flyleaves. Only after the rise of the nineteenth-century public library did such acts come to be seen as defacing, rather than enriching, the book. Today, "social bookmarking" tools like Delicious

and Diigo once again allow readers to tag, index, and highlight books, in forms accessible (and answerable) to future readers. One journalist recently faulted the Kindle for lacking "the impressions of previous readers, the smudges and folds and scribbles and forgotten treasures tucked amid the pages." Yet digital heatmaps convey the same information once suggested by wear and tear: if you annotate a passage on your Kindle, for example, a pop-up informs you how many other people have underlined it before.

We read over the shoulders of giants; books place us in dialogue not just with an author but with other readers. Six months from now, this book may be supplanted by a Facebook site. What seems unlikely to change is our curiosity about what friends and strangers read—or about what others will make of our own reading.

Alison Bechdel

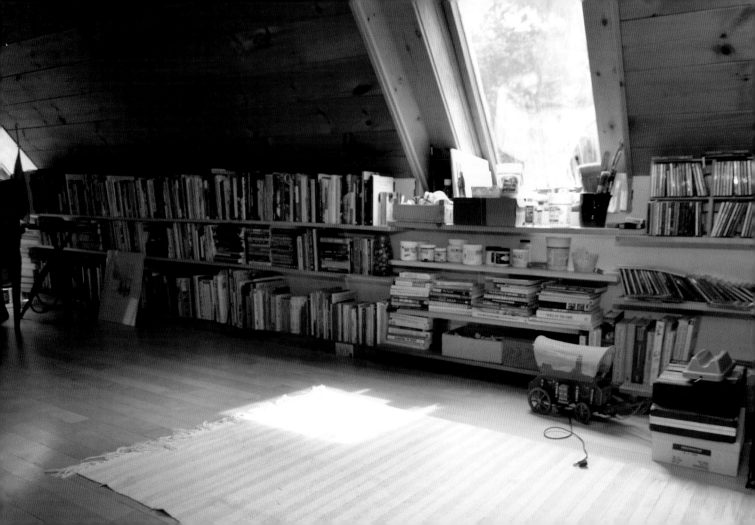

LEAH PRICE: Of all the bookshelves I've seen for this project, yours are the most obsessively organized. Their arrangement juxtaposes the high and the low, the ephemeral and the scholarly, but there's nothing haphazard about the efficiency with which you have categorized, for example, "tits and clits" in one box and "misc. boy" in another. Does this extend to the way you organize your other possessions? Do you color-code your spices, alphabetize your socks?

ALISON BECHDEL: It's ironic that I categorize my library so rigidly because I've often griped about the way my own work gets pigeonholed in bookstores. My *Dykes to Watch Out For* cartoon books tend to end up in the LGBT Studies section instead of in Humor or Graphic Novels. And my memoir *Fun Home* might be anywhere. In one big chain store, I was disappointed not to find it in the graphic novel section—but then I found it in New Biography, and was delighted to see it being treated as a regular, nongraphic book.

I was at a younger friend's house recently and noticed that she had fiction, nonfiction, and

graphic novels all shelved together in alphabetical order by author. This seemed like a very evolved way of doing things, and made me feel sheepish about the way I've ghettoized my own collection of comics and graphic novels. Yet I don't feel quite ready to abandon all categories.

My library starts with fiction in the living room. Then the shelves jump up to the landing of the stairs and continue with memoir, autobiography, some random nonfiction and anthologies. Then comes art theory, cultural criticism, film and lit crit, linguistics, psychoanalysis, mythology, philosophy, religion. I used to connect these books like Legos in a particular progression that felt like a model of my intellectual framework—my interest in how words and pictures work together, how stories and ideas inform each other. Barthes's *Image, Music, Text* was the keystone holding it all up. It felt very helpful to have this little schema that I could adjust and rearrange as my thinking evolved.

Next comes my small current affairs and political science section, then feminism. Upstairs is my fairly extensive queer theory/LGBT studies section. This had gotten way out of control in recent years: a jumble of history, theory, art, sex, lesbian, gay, and transgender stuff. It was impossible to find anything. Then I had the brilliant idea to organize it all by publication date. Not only can I find things instantly now, but the spines create a curiously eloquent timeline of the Zeitgeist over the past thirty years—from Jill Johnston's *Lesbian Nation* (1973) to *When Gay People Get Married* (2009). I mean, really: what more is there to say?

You have an elaborate bookstand, one that seems designed to facilitate writing in tandem with reading. How and how much do you mark up your books, pencil, sticky note, highlighter, bus ticket? Are there books in which you wouldn't write?

Actually, I got that industrial strength Atlas Ergonomic Bookstand to facilitate reading in tandem with *eating*. I got tired of trying to prop a book open and use a knife and fork at the same time.

But I am in fact an excessive marker-up of books. I don't feel like I've quite made a book my

own until I've bespangled it with Post-its, illuminated it with at least three different colors of highlighters, and scrawled lots of question marks and exclamation points all over the place. I do lend my books out, but I have to be a bit selective because my marginalia are so incriminating.

I can't bear losing a volume, though, and I keep track of what goes out. In my senior year of college I let a friend borrow my Symbolic Logic textbook. We fell out of touch, and for twenty years, I missed that book almost every day. I was sure it would clarify so many of my murky, half-formed ideas. Then several years ago I ran into that old college friend! I felt a little churlish for asking, but she still had the book, and she agreed to return it to me. Getting it back gave me a profound sense of peace, but of course I haven't looked at it since.

How far back does your collection stretch? When were the first books that you still own acquired? At what age did you start buying books? Which ones have you kept, and shed, as you moved? At what phases of your existence has reading books, and owning books, been most important to you? Have there been periods of your life when you stopped reading?

Mad magazine used to advertise paperback cartoon collections—*Son of Mad, Self-Made Mad, Howling Mad, The Indigestible Mad*—and I started sending away for them when I was eight or nine. Sadly, these have all disappeared along the way somewhere. The next thing I remember buying for myself was an 1898 edition of Skeat's *Etymological Dictionary* in a used book shop the summer I was seventeen. I've always been partial to dictionaries. In college I was lured into the Quality Paperback Book Club by their offer of the compact edition of the Oxford English Dictionary for fifty cents. It was well worth the additional hundreds of dollars I spent on books I didn't want before I figured out how to cancel their automatic monthly shipments.

Once, in my twenties, I read an article about how all our paperbacks would start disintegrating in fifteen years or so. That disturbed me, but I couldn't afford hardcovers. And now, of course, it

turns out the article was right. All my old paper-backs are falling apart. I just had to throw out completely pulverized copies of *Pride and Prejudice* and *Anna Karenina*. I wish I'd thought to put them in the compost heap—they would surely have yielded some inspiring vegetables.

Could you say something about the books you selected for our top ten? Which of your books are the most important to you? Which are the ones you miss the most when you're away from home?

I picked Rich, Freud, Sontag, and Barthes because they were so influential to me in my youth, and had such a profound effect on my thinking as a feminist, as an autobiographer, and as a visual storyteller.

When my father explained *Roget's Thesaurus* to me, it was like he'd unlocked the universe. I can't write without this book. In fact, it's a sign that I've finally begun concentrating when I have to get up and consult the thesaurus. I don't use it just for synonyms, but to help me think through ideas, to find

a word that serves as a stepping-stone to another word that will send me off in a new direction.

I can hardly speak about *To the Lighthouse*. Every time I reread it, I discover a new level of meaning that I wasn't equipped to understand before. Like I'm growing into it or along with it, as if it's a friend or lover I'm traveling through life with.

The Unstrung Harp is an illustrated story about an author writing and publishing his biennial novel. One of my favorite panels is when Mr. Earbrass goes tearing through his library in the middle of the night for some lines of poetry. "His mind's eye sees them quoted on the bottom third of a right-hand page in a (possibly) olive-bound book he read at least five years ago."

I don't actually own the edition of *The Price of Salt* that I've drawn here. My copy is a very dull looking feminist reprint from the eighties. But if I can ever afford to collect rare books, this one's at the top of my list.

It's a lesbian romance that Patricia Highsmith wrote in 1952. Her first book, *Strangers on a Train,* was a creepy suspense novel with a homoerotic subtext that got made into a Hitchcock film in 1951. She didn't want to get pigeonholed as a lesbian writer, so she published the romance under a pseudonym. It didn't really take off until it was published in paperback, though, with this racy pulp-fiction cover.

It's a heartbreaking book—it's not just the first homosexual love story to have a happy ending, but it feels to me like a glimpse of an intact part of Highsmith that wasn't able to survive in a hostile world. Instead, she spent her life writing creepy suspense novels with homoerotic subtexts like *Strangers* and her famous *Ripley* series. Actually, repressed homosexual love seems to be a theme among the books I've listed here.

Always, Rachel is a collection of the correspondence between Rachel Carson and her close friend Dorothy Freeman. It begins when they first meet, and it's immediately clear that they've fallen madly in love. But Freeman is married and Carson is too busy to have a relationship even if she knew— and was able to accept—that she was a lesbian. The chief charm of *The Dharma Bums* for me, likewise, is the

frustrated and unspoken romantic love that Jack Kerouac clearly feels for Japhy Ryder—the thinly disguised Gary Snyder. If this had been open or acted upon, their backcountry bodhisattva adventures would somehow be not quite as compelling.

Temperamentally, are you a pack rat or a toss rat? Do you store other kinds of media, cassette tapes, LPs, CDs, or do you download and discard? How do you dispose of the books you don't want, donating, recycling, putting out on the curb . . . ? Do you have any taboo against throwing away books when you're done reading them, or replacing books when they fall apart from wear and tear?

I rarely throw anything away. I did sell most of my LPs and my turntable back in the eighties, and have regretted it ever since. So now I try to hang onto stuff, but I'm very troubled by my extensive collection of obsolete media, and I'm frustrated that most of my digital archive is essentially inaccessible to me—for example, my early AOL e-mails. I keep hoping a passionate archivist will develop some kind of Rosetta Stone application to decipher all these obsolete applications.

What do you imagine your library looking like five, ten, twenty years from now? Do you think you'll still own objects made of paper and glue? And, with apologies for a morbid question, do you ever think about what will happen to your library after your death?

Unless I die very soon, which is of course entirely possible, I'm afraid my shoddy paperback library will decompose before I do.

Top Ten Books
Alison Bechdel

Martha
Freeman, ed.
Always, Rachel:
The Letters of
Rachel Carson and
Dorothy Freeman,
1952–1964; The
Story of a Remark-
able Friendship

Jack Kerouac
The Dharma Bums

Adrienne Rich
On Lies, Secrets,
and Silence:
Selected Prose
1966–1978

Susan Sontag
On Photography

Claire Morgan
The Price of Salt

Sigmund Freud
Psychopathology of
Everyday Life

Roget's Thesaurus
of Words and
Phrases

Roland Barthes
Roland Barthes

Hergé
Tintin in Tibet

Virginia Woolf
To the Lighthouse

Edward Gorey
The Unstrung Harp;
or Mr. Earbrass
Writes a Novel

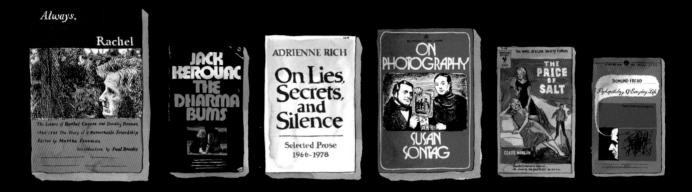

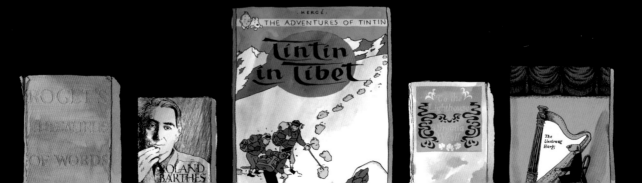

BLEAK
HOUSE

CHARLES
DICKENS

INTERNATIONAL
COLLECTORS
LIBRARY

The Charles Dickens Companion HARDWICK D 213

esperados

D 77

Pilgrim at Tinker Creek: Annie Dillard. 551 09500 195

EMMA
DONOGHUE

Slammerkin Harcourt

HOOD EMMA DONOGHUE Harper Collins

HOOD emma donoghue alyson books

EMMA DONOGHUE *Landing* Harcourt

WE ARE MICHAEL FIELD EMMA DONOGHUE ABSOLUTE PRESS

STIR-FRY EMMA DONOGHUE

DOSTOYEVSKY THE BROTHERS KARAMAZOV G 36

REBECCA DAPHNE DU MAURIER Perennial

Emily Eden The Semi-Attached Couple & The Semi-Detached House

DAVE EGGERS A HEARTBREAKING WORK of STAGGERING GENIUS VINTAGE

THE MILL ON THE FLOSS

ELIOT · MIDDLEMARCH

GOREY x 3

THE AMERICAN PURITANS

PERRY MILLER

Translated by C. DAY LEWIS

Anchor
A 89

Translated by C. DAY LEWIS

Anchor
A 20

Anchor
A 20

YOU KNOW WHO

CIARDI

You read to me, I'll read to you

LIPPINCOTT

LIPPINCOTT

Edward Gorey

The Unstrung Harp

THE GASHLYCRUMB TINIES by Edward Gorey

HARCOURT
BRACE

THE AWDREY-GORE LEGACY

EDWARD GOREY

DODD, MEAD

THE INSECT GOD by Edward Gorey

Beaufort

EDWARD GOREY/THE GLORIOUS NOSEBLEED/DODD, MEAD

The Betrothed/Ink Gorey Signs and Details

THE GILDED BAT

EDWARD GOREY

DODD, MEAD

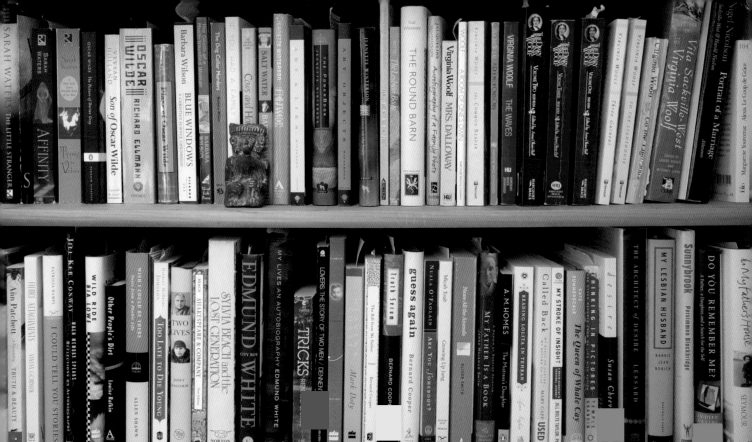

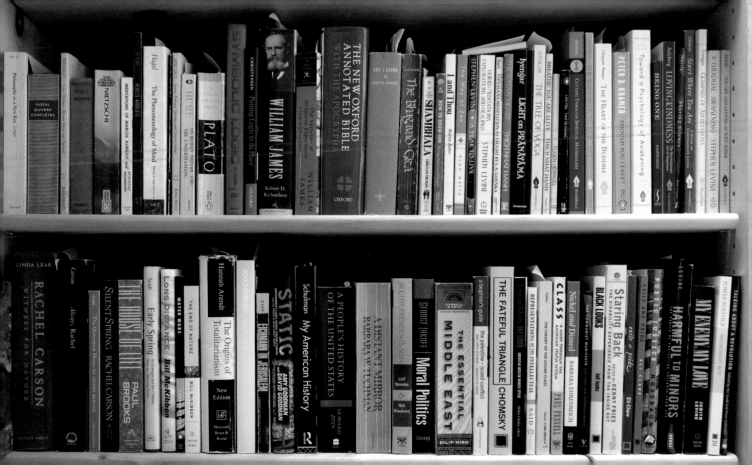

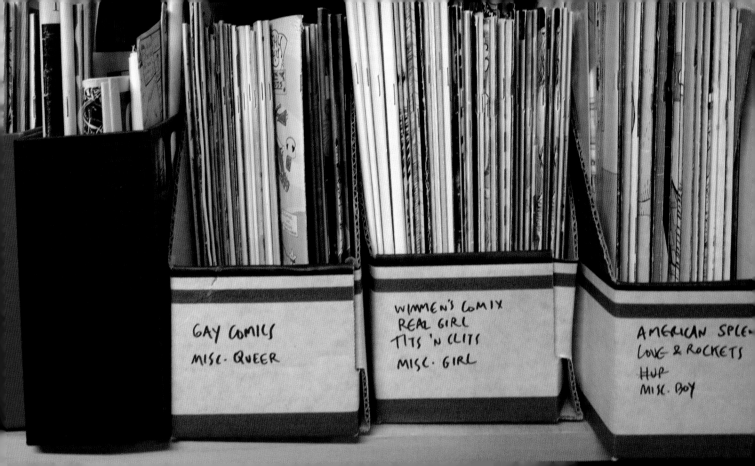

GAY COMICS
MISC. QUEER

WIMMEN'S COMIX
REAL GIRL
TITS 'N CLITS
MISC. GIRL

AMERICAN SPLE-
LOVE & ROCKETS
HUP
MISC. BOY

Stephen Carter

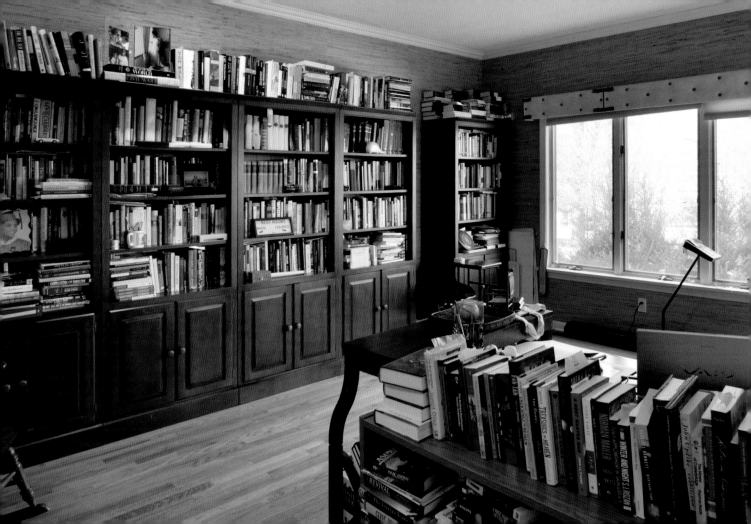

LEAH PRICE: How far back does your collection stretch? When were the first books that you still own acquired? At what age did you start buying books? Which ones have you kept, and shed, as you moved?

STEPHEN CARTER: In the beginning, I bought comic books. The first books that I made any effort to collect were the *Tom Swift* books. This would have been in the early and mid-sixties, when I was still in grade school. Although they are now mostly boxed away, I still own nearly every book I ever bought for a high school, college, or law school course, apart from a few science and mathematics texts that I sold during my undergraduate years. I find myself constitutionally unable to part with a book. My office at Yale is heaped with books. So is our basement at home. Several boxes of old paperbacks molder in our garage.

At what phases of your existence has reading books, and owning books, been most important to you? Have there been periods of your life when you stopped reading?

When I was in fifth or sixth grade, I took down from my father's bookshelf a copy of Nietzsche's *Man and Superman*. No doubt I hoped for adventures of a comic book hero. I could not understand a word of the text, of course, but I have a sharp memory of deciding, at that instant, that I would someday understand such books.

Could you say something about the books you selected for our top ten?

Bryce, *Modern Democracies* (two volumes, first edition, 1921). It is our habit to treat Alexis de Tocqueville as the great European observer of America, but Bryce is far more penetrating.

Lewis, *The Screwtape Letters*. I go back and reread this epistolary novel at least every other year, and each time I learn something new—about morality, or about writing, or about faith.

Hogben, *Mathematics for the Million* (1940 revised edition). One of the volumes I loved taking down from my father's shelves. What is truly remarkable about the book is that although it was written to popularize mathematics, it was published before the age of dumbing-down, with the result that Hogben covers a number of quite sophisticated mathematical techniques. The book is not easy going, but so what? There was a time when lots of people would have struggled through it anyway. Today's popular works on similar subjects are often designed to spoon-feed people, worried, no doubt, about the modern attention span. Ugh!

Sandburg, *Abraham Lincoln: The War Years* (four volumes, 1939). Another book I learned from my father to love. I used to take down his set of Sandburg and leaf through it at random.

The Holy Bible. The one on my shelf is a rather worn King James Version. In a case at my office at Yale are some even older copies. I am by no means a formal Bible collector. I am a Bible reader.

Mannheim, *Ideology and Utopia*. I read this book for a seminar back in college. To this day, I have yet to encounter a better statement of the many ways in which ideological commitment puts at risk the entire project of the Enlightenment—and therefore of liberal democracy.

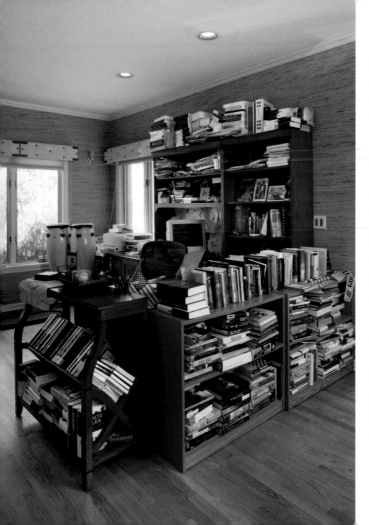

The Book of Common Prayer (1928 version). Episcopal churches today are not permitted to use the 1928 prayer book, except by special permission of the bishop, but the modern versions are so watery that they have hardly any theological content.

Bonhoeffer, *Ethics*. The book that remained unfinished when he died in a Nazi camp.

Russell, *In Praise of Idleness and Other Essays*. The title essay to this volume argues that we must leave time in our busy lives for doing nothing—not reading, or painting, or Facebooking, but doing nothing—letting our minds wander—or we will never be able to understand clearly what we ourselves think.

The Complete Works of William Shakespeare (Oxford Press edition, 1938). What can I say?

How do you arrange, or attempt to arrange, your books? How do you know how to find them on the shelf, if indeed you do know? (Alphabetical order, subject, size, chance . . . ?) Does this resemble the way you arrange (or don't) your other possessions?

My books are not, for the most part, arranged. The Lincoln books are together on a couple of shelves, as are the chess books. (I also have several chess shelves in the basement, and another at my office.) But everything else has been shoved where it could fit. It does not bother me that I might have trouble finding a particular book. How dull to have everything at one's fingertips! To never be surprised, to never say to yourself, "I had forgotten I even owned a copy of this!"

Do you use an e-reader (Kindle, iPad, et cetera)?
Do you read books on your phone?

No Kindle. No iPad. No phone smart enough for books.

I would like to add a small story.

I learned to read at an early age—much earlier, my mother always said, than most children would. But for many years, what I read was, quite simply, junk. Comic books when I was small, science fiction when I reached my teens. Then, when I was in tenth grade (at Ithaca High School), my English teacher, Mrs. Judith Dickey, took me aside and asked why I wasted my mind on the sort of books I read. Naturally, I took umbrage: who was she to say that her taste was superior to mine? Mrs. Dickey offered a challenge. She would read any three books I gave her if I would read any three books she gave me.

I agreed.

My life was changed. The books she gave me opened my mind to the simple realization that there is in the world such a thing as truly great literature; and that I would never discover it by mere hit-or-miss, or by reading only what interested me.

(By the way, when I tell this story, somebody always asks which books Mrs. Dickey assigned me. The terrible part is that I really have no idea. That was a good forty years ago, and although I remember quite clearly my response to the books, I cannot call to mind a single title.)

Top Ten Books
Stephen Carter

Carl Sandburg
Abraham Lincoln:
The War Years,
vols. 1–4

Book of Common
Prayer

William
Shakespeare
The Complete Works

Dietrich
Bonhoeffer
Ethics

Holy Bible (King
James Version)

Karl Mannheim
Ideology and Utopia

Bertrand Russell
In Praise of Idleness

Lancelot Hogben
Mathematics
for the Million:
How to Master the
Magic of Numbers

Viscount Bryce
Modern Democracies
(in 2 vols.)

C. S. Lewis
The Screwtape
Letters

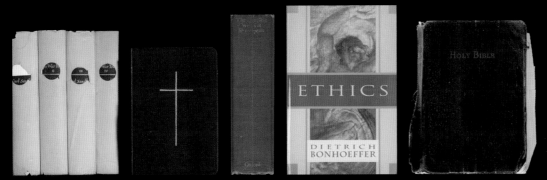

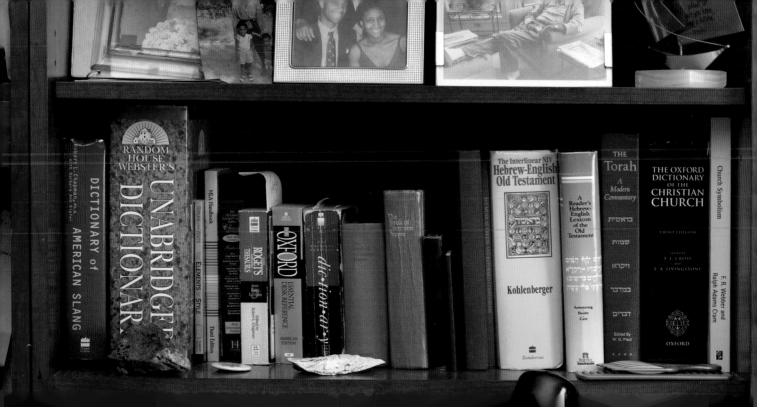

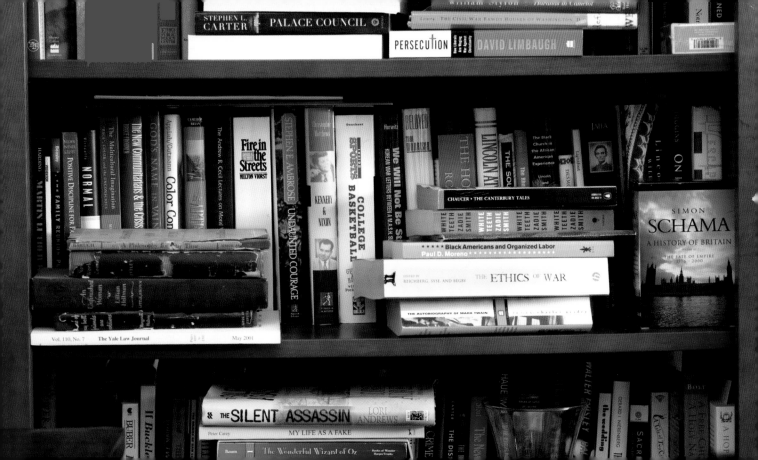

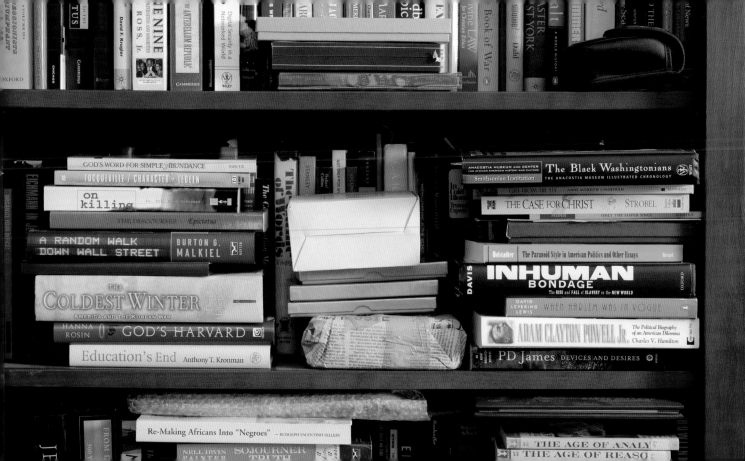

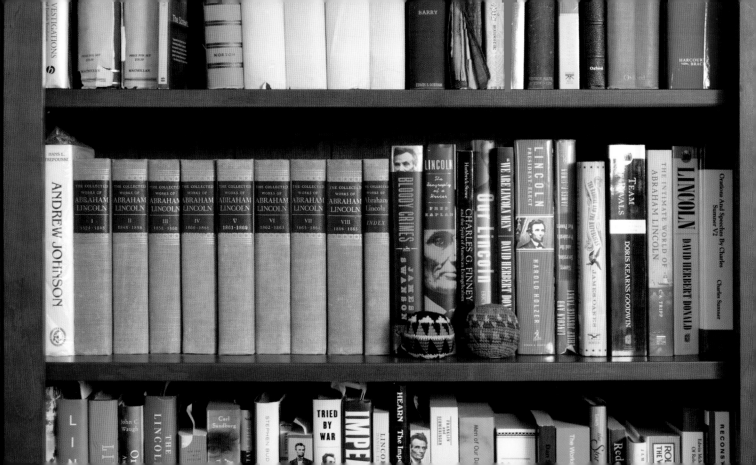

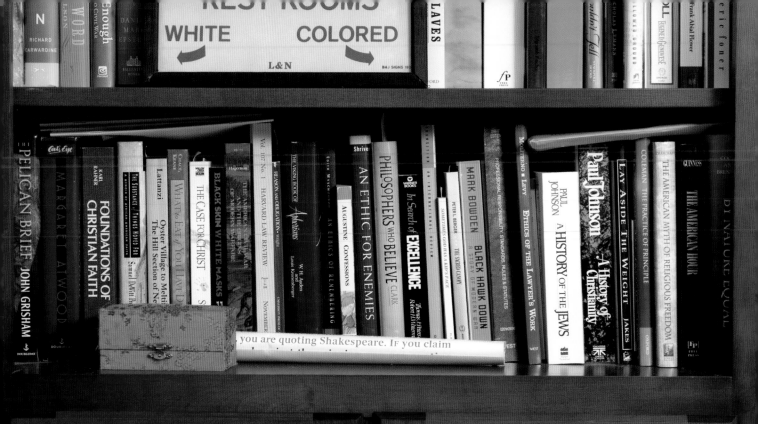

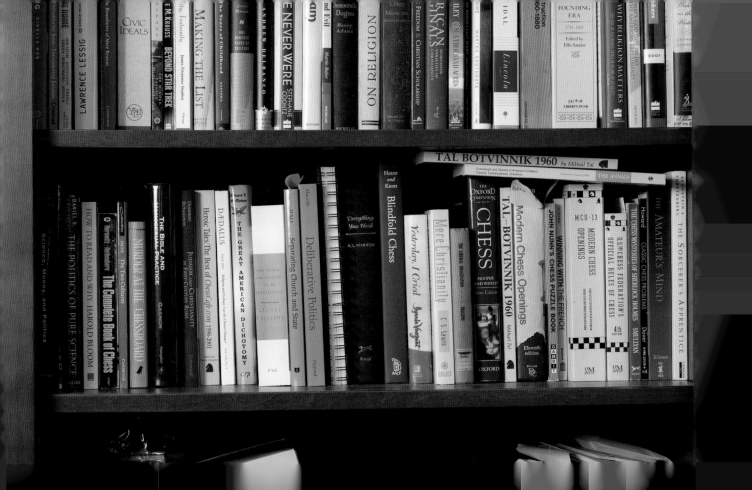

Junot Díaz

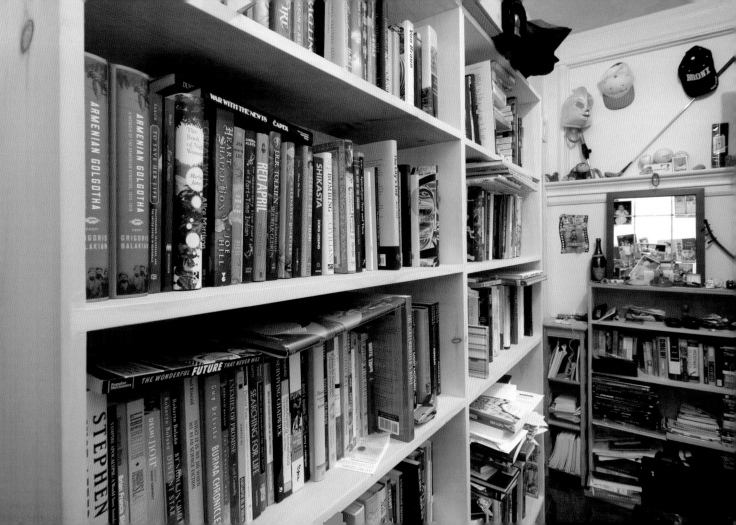

LEAH PRICE: *The Brief Wondrous Life of Oscar Wao* can be seen (among many other things) as a reflection on what it means to be a "reader/fanboy." One character says, "I should have known not to trust anybody whose favorite books as a child were *Encyclopedia Brown*." How far back does your collection stretch?

JUNOT DÍAZ: I have in my collection some of the first books I ever owned, 1975, though my true first books, a set of *Collier's Encyclopedia* from 1965, given to me by a neighbor with volumes 6 and 12 missing, were lost during one of my first moves.

I started acquiring books as soon as I started earning my own money. I was twelve, I guess. Had a couple of paper routes. I cannot exaggerate how poor my family was in my childhood, and there were days when it was a toss-up between food and books—and like Erasmus I tended to buy books first. I still remember buying all the *Elric* paperbacks and all the *John Carter of Mars* books from a Waldenbooks in a nearby mall—that took a while. Despite all the times I have moved, I never shed books except once, after I left New Jersey

more or less for good. I still mourn all those books I chucked. And I have over the years slowly pulled other copies of these books back into my life. But there are some I've never recovered, whose names I've forgotten, only the picture on the cover remains.

I certainly couldn't have survived my childhood without books. All that deprivation and pain—abuse, broken home, a runaway sister, a brother with cancer—the books allowed me to withstand. They sustained me. I read still, prolifically, with great passion, but never like I read in those days: in those days it was life or death.

I also read immensely when I was floundering with my novel *Oscar Wao*. In the darkness of those years books were lanterns, they were lighthouses.

What books are *not* on the shelves you allowed us to photograph? Are there kinds of books you keep in places other than the bookshelf—cookbooks, phone books, pornography? What kinds of books do you keep in the kitchen, in the bathroom, on the bedside table?

I actually own no out-and-out pornography. If I did, I'd probably have it out on my shelves. I've never liked the idea of a hidden book. It means no one will ever randomly pick it up and have a conversation with you about it. I know you guys didn't look too closely on one shelf, because there were stacks and stacks of role-playing games on it. Some of those are more cringe-inducing than any page-worn copy of *Hustler*.

In the bathroom I keep books that I can read quickly. In the kitchen I have paperback genre—horror, fantasy, young adult, science fiction, and some British literary fiction. And some black nationalist conspiracy books. Next to my bed I keep the page-turners, the thrillers and such.

Eventually everything I have gets read. But naturally I buy more than I can read, so there is always at least a hundred-book margin between what I own and what I've read. What's cool is that I've caught up a couple times, and this year I intend to catch up again. But then I'll buy too much and the race starts again.

You mentioned that you've moved recently, and that these shelves represent only a fraction of your collection. How did you decide what to take? Which books not here do you miss the most?

I took about twenty books that I needed for my well-being (Delany, Morrison, Edward Rivera, Roy, et cetera) and rebuilt from there. I have so many books in storage. I miss having them around. I won't know which book I missed the most until I get them back. I'll mourn after the reunion. Which is kinda strange, but typically me.

Have you ever listened to audiobooks? If so, where and when? Do you enjoy reading aloud or being read aloud to?

When I was still with my ex, I drove back and forth between New York and Cambridge seven to eight times a month, and that's how I got into audiobooks. I had to stick to the oral tales—*Beowulf, Gilgamesh*—and to the adventure books and thrillers. Anything else would put me to sleep, since I read in my head a lot faster than folks read aloud.

I liked reading to my ex. Never read to anyone else. Never had anyone read to me, really.

You must be drowning in more complimentary copies than you have time or desire to read. When someone you care about gives you a book, do you feel obliged to read it? How do you dispose of the books you don't want—donating, recycling, putting out on the curb . . . ? Do you have some taboo against throwing away books when you're done reading them? Conversely, when a book falls apart from use, do you repair it, or are you just as happy to buy a new copy?

I read pretty damn fast, so when a friend gives me a book of theirs, I shoot through it ASAP. Less trouble that way, and causes me no grief, so why not just do it? I give books away. I live in a literary building, I'll tell you that, and whatever they don't want I give to a homeless couple on the square who sell books for a living. Ever since I threw books away during my Leaving Jersey move,

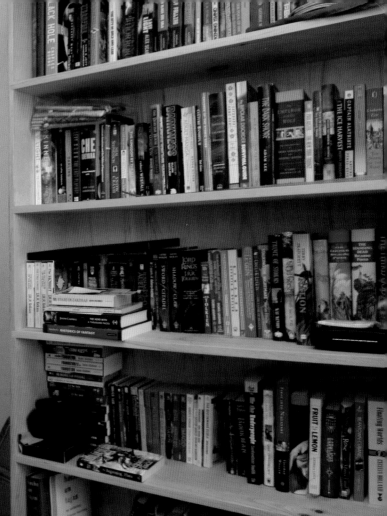

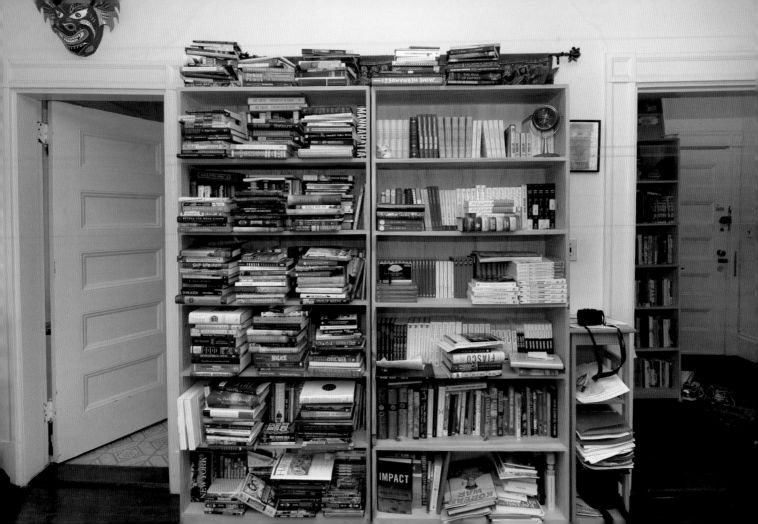

I swore never to throw books away. Galleys I can throw away. But not books. I only throw away books that are too damaged to read, and I try to prolong their lives with tape. I have some Frankensteins around here you just wouldn't imagine.

What do you imagine your library looking like five, ten, twenty years from now? Do you think you'll still own objects made of paper and glue? Do you think comic books, in particular, will survive in hard-copy form?

I figure books survived the Dark Ages—why couldn't they survive the Age of Darkest Capital? Books for me are many things: they are friends, they are companions, they are mentors, they are warnings, they clown, they entertain, they hearten, and they make me stronger. But most of all books (I say again and again) are like the Thirty-Mile Woman from Toni Morrison's *Beloved:* "She is a friend of my mind. She gather me, man. The pieces I am, she gather them and give them back to me in all the right order."

Top Ten Books
Junot Díaz

Tom Athanasiou
Divided Planet:
The Ecology of Rich
and Poor

Edward Rivera
Family Installments:
Memories of Grow-
ing Up Hispanic

Thomas G. Karis
and Gail M.
Gerhart
From Protest to
Challenge: A Docu-
mentary History of
African Politics in
South Africa, 1882–
1990, vol. 5, Nadir
and Resurgence,
1964–1979

Arundhati Roy
The God of Small
Things

Marguerite
Feitlowitz
A Lexicon of Terror:
Argentina and
the Legacies
of Torture

J. R. R. Tolkien
The Lord of the Rings

Gilbert Hernan-
dez and Jaime
Hernandez
Love and Rockets,
no. 12, Poison River

Samuel R. Delany
The Motion
of Light in Water:
Sex and Science
Fiction Writing in
the East Village

Eric Greene
Planet of the Apes
as American Myth:
Race, Politics, and
Popular Culture

Maxine Hong
Kingston
The Woman
Warrior: Memoirs
of a Girlhood
Among Ghosts

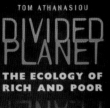

TOM ATHANASIOU

DIVIDED
PLANET

THE ECOLOGY OF
RICH AND POOR

"The single most accessible presentation of what is known as 'social ecology' that has yet been written."—The Nation

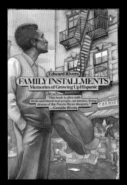

Edward Rivera
FAMILY INSTALLMENTS
Memories of Growing Up Hispanic

"This book is alive with flesh-and-blood real people...an intense, living drama of the Puerto Rican diaspora."
—Geraldo Rivera

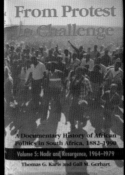

From Protest
to Challenge

A Documentary History of African
Politics in South Africa, 1882–1990

Volume 5: Nadir and Resurgence, 1964–1979

Thomas G. Karis and Gail M. Gerhart

NEW YORK TIMES BESTSELLER

THE GOD
OF
SMALL THINGS

A NOVEL

ARUNDHATI
ROY

a lexicon of terror

argentina and the legacies of torture

marguerite feitlowitz

GILBERT HERNANDEZ

POISON RIVER

A Love and Rockets Collection

SAMUEL

SEX AND
SCIENCE FICTION
WRITING
IN THE EAST
VILLAGE

THE MOTION OF LIGHT IN WATER

DELANY

PLANET OF THE APES
as American Myth
Race, Politics, and Popular Culture

Eric Greene

FOREWORD BY RICHARD SLOTKIN

THE
WOMAN
WARRIOR

MEMOIRS OF A
GIRLHOOD
AMONG GHOSTS

MAXINE
HONG
KINGSTON

THE TWO TOWERS THE FELLOWSHIP OF THE RING THE RETURN OF THE KING

J.R.R. Tolkien

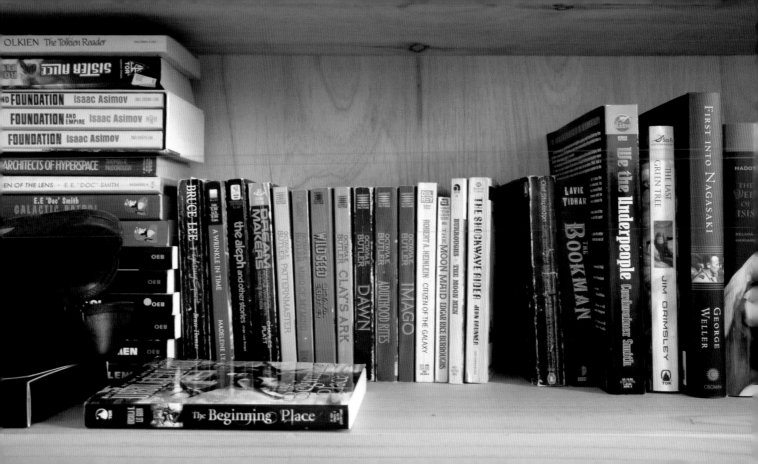

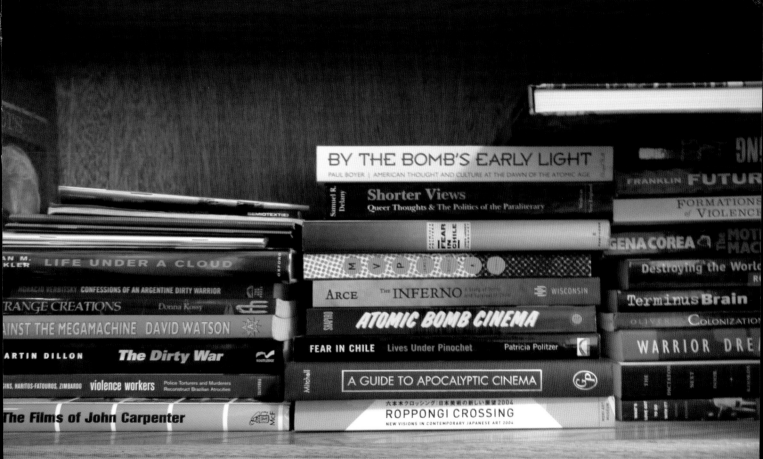

BY THE BOMB'S EARLY LIGHT
PAUL BOYER | AMERICAN THOUGHT AND CULTURE AT THE DAWN OF THE ATOMIC AGE

Samuel R. Delany | **Shorter Views**
Queer Thoughts & The Politics of the Paraliterary

FRANKLIN **FUTUR**

FORMATIONS
of VIOLENCE

FEAR IN CHILE

LIFE UNDER A CLOUD

GENA COREA THE MOTH MAC

M V P

Destroying the World

HORACIO VERBITSKY CONFESSIONS OF AN ARGENTINE DIRTY WARRIOR

ARCE THE INFERNO A History of ... WISCONSIN

RANGE CREATIONS Donna Kossy

Terminus **Brain**

AINST THE MEGAMACHINE DAVID WATSON

SHAPIRO **ATOMIC BOMB CINEMA**

OLIVER COLONIZATION

ARTIN DILLON **The Dirty War**

FEAR IN CHILE Lives Under Pinochet Patricia Politzer

WARRIOR DREA

INS, HARITOS-FATOUROS, ZIMBARDO **violence workers** Police Torturers and Murderers
Reconstruct Brazilian Atrocities

Mitchell A GUIDE TO APOCALYPTIC CINEMA

The Films of John Carpenter

六本木クロッシング:日本美術の新しい展望 2004
ROPPONGI CROSSING
NEW VISIONS IN CONTEMPORARY JAPANESE ART 2004

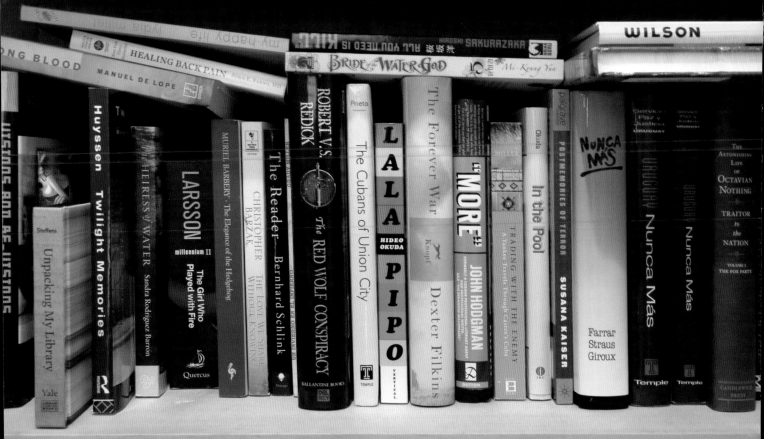

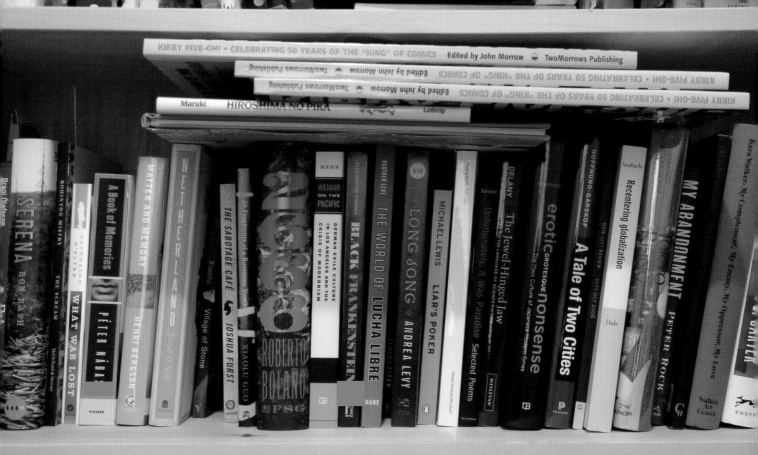

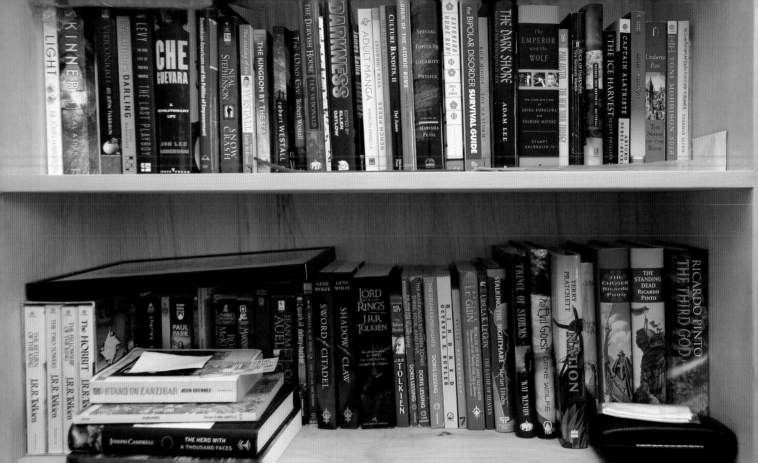

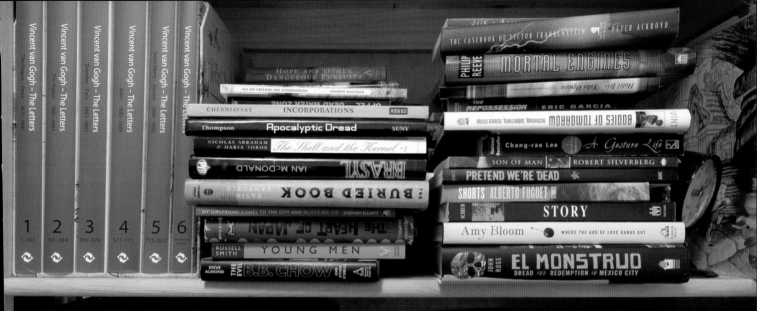
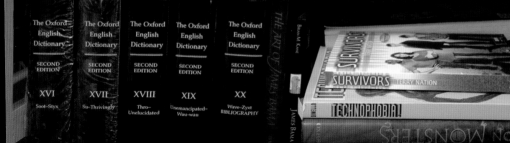

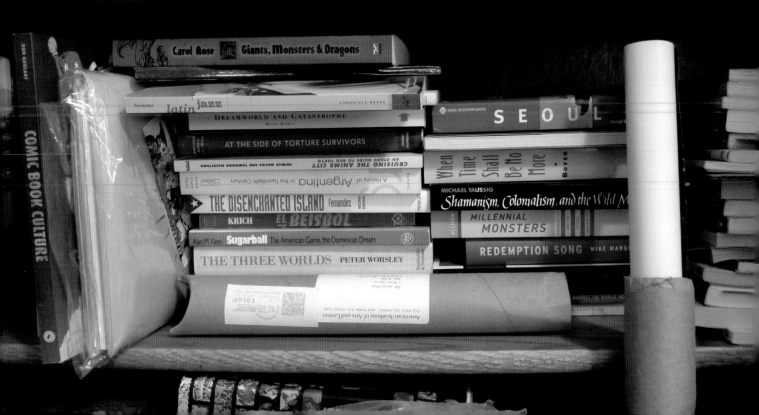

Huggins, Haritos-Fatouros, Zimbardo — Violence Workers

MU__ The Films of John Carpenter

ROPPONGI CROSSING

RON GOULART

COMIC BOOK CULTURE

Fernández — latin jazz — CHRONICLE BOOKS

DREAMWORLD AND CATASTROPHE — Susan Buck-Morss

AT THE SIDE OF TORTURE SURVIVORS

PATRICK MACIAS AND TOMOHIRO MACHIYAMA — CRUISING THE ANIME CITY — An Otaku Guide to Neo Tokyo

A History of Argentina in the Twentieth Century

THE DISENCHANTED ISLAND — Fernández — SECOND EDITION

KRICH — EL BEISBOL

Alan M. Klein — Sugarball — The American Game, the Dominican Dream

THE THREE WORLDS — PETER WORSLEY — Weidenfeld & Nicolson

Carol Rose — Giants, Monsters & Dragons

SEOUL SELECTION GUIDES — SEOUL

When Time Shall Be No More — BOYER

MICHAEL TAUSSIG — Shamanism, Colonialism, and the Wild M

ALLISON — MILLENNIAL MONSTERS

REDEMPTION SONG — MIKE MARQ

American Academy of Arts and Letters
633 West 155th Street — New York, N.Y. 10032-7599
$0164

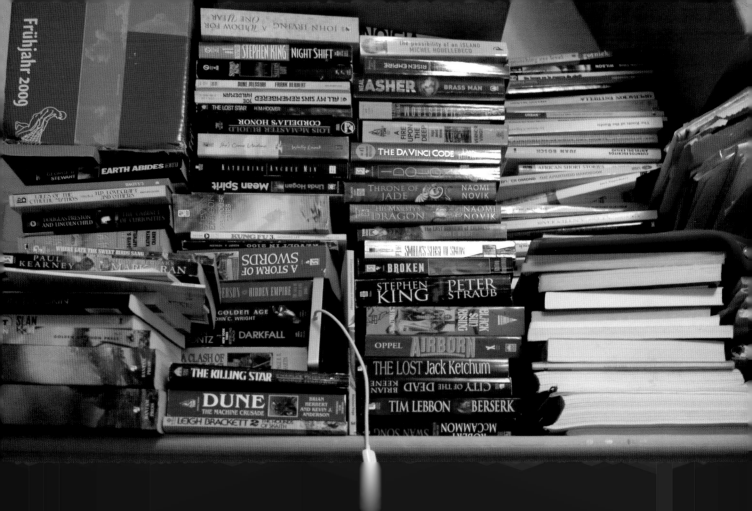

Rebecca Goldstein & Steven Pinker

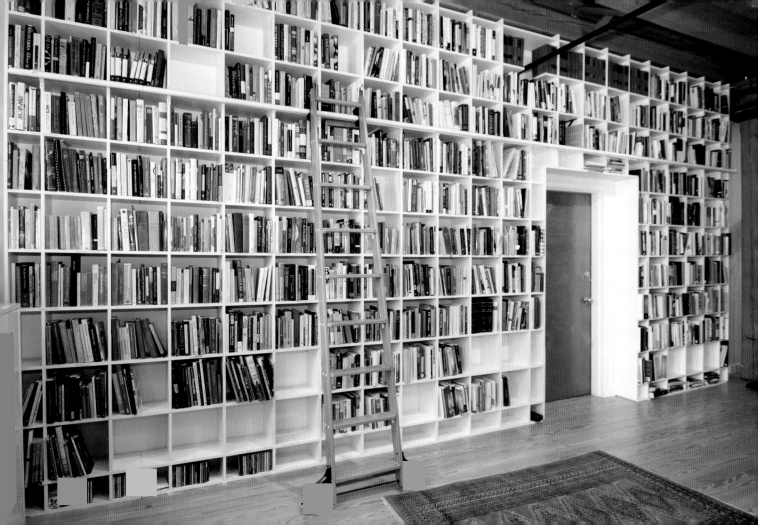

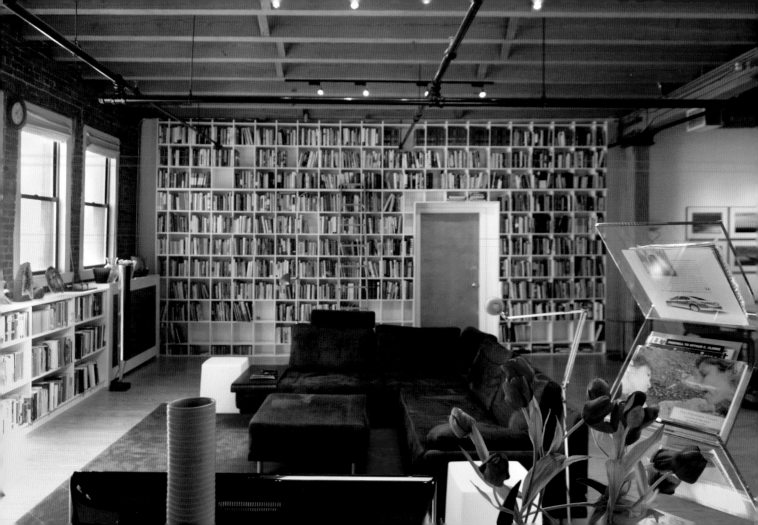

An Interview with
Rebecca Goldstein

LEAH PRICE: How far back do your collections stretch? When were the first books that you still own acquired? At what age did you start buying books? Which ones have you kept, and shed, as you moved? At what phases of your existence has reading books—and owning books—been most important to you? Have there been periods of your life when you stopped reading?

REBECCA GOLDSTEIN: I grew up in a family that considered book buying a luxury for rich people. We used the public library. So I remember vividly when I started buying books, which was at age fourteen. I had a regular job babysitting and was also teaching Sunday school. My parents regarded my earnings as my own, and I was able to use the money to buy books. I even remember the very first book: Thoreau's *Walden*. That memory jogs another: an interviewer asking me, when I'd gotten a MacArthur prize, what I would use the money for. The first thing I could think of was an edition of William Yeats's *Collected Works* that I'd been longing for. I had had money worries at that time, and hadn't felt prepared to buy it.

At this point in my life, I'm pretty lucky. I buy whatever books I want. But I'm still careful. I have all sorts of scruples connected with books and know that whatever I acquire I'll probably never get rid of.

I still have those first acquisitions, bought with babysitting money. For example, there's *Radical Theology and the Death of God,* by Thomas J. J. Altizer and William Hamilton. I think I bought that book for the shock value of its title. And the cover is bright red, too. I was going to an extremely religious all-girls high school, and I brought the book with me to read in the back of the classroom, just daring the teacher to find it and ask me about it. I was itching for a fight, but she had the good sense to ignore me.

There's never been a time when I'd stopped reading, although sometimes I do stop reading fiction. For example, when I was completing my doctoral dissertation in philosophy, I forbade myself any distracting fiction. When I finished the dissertation, I went on a fiction feeding frenzy. I must have felt starved. I couldn't stop gorging on big, fat, highly caloric nineteenth-century novels.

I finished *Jude the Obscure* and immediately began *The Golden Bowl.*

Could you say something about the books you selected for our top ten? Which of your books are the most important to you? Which are the ones you miss the most when you're away from home? Which are the ones you would grab first if a fire broke out? Why?

My copies of both Spinoza's *Ethics* and David Hume's *Treatise on Human Nature* are the same ones I had in college. I've used them so much—taught from them, consulted them—that they are crumbling. And my translation of the *Ethics* is not the one that most scholars use now. There's a superior one. So when I write scholarly articles and quote from my translation, the editors often object. But I can't give it up. It's those words, of that translation, whether inferior or not, that are, for me, Spinoza's words. Those are the ones I've memorized. And both those books, the Spinoza and the Hume, are filled with my marginalia, going all the way back to college. There are passages that

I'd marked with questions, and then, sometimes years later, there's the answer I came to. I've never kept a diary. These books, with their marginalia, are the closest thing I have to a diary.

What books are *not* on the shelves you allowed us to photograph? Are there kinds of books you keep in places other than the bookshelf—cookbooks, phone books, pornography? What kinds of books do you keep in the kitchen, in the bathroom, on the bedside table? Conversely, what nonbook objects do you keep on the bookshelves?

We have some cookbooks—rarely consulted these days, I'm afraid—in the kitchen. (We live near Chinatown; takeout is too tempting.) My bedside table has the books I'm currently reading. I tend to be reading two or three at a time, though only one novel at a time. There was a time when we had some vases and candlesticks mixed in with the books, but I didn't like that at all. It seemed to me to qualify as what philosophers call a "category mistake." Books are really the only place in my life where I need rigorous order. My own writing is like that, too, I suppose. I have to be very clear in my mind on the internal structure. It must all be coherent.

Do you lend your books to friends?

I used to lend books to students all the time. I loved to ply them with books, but I lost a great number that way, some of them with marginalia that I regret losing. I lend books now, but mostly just to my two daughters. I rarely get those books back either, but somehow that's different.

You remark in *Thirty-Six Arguments for the Existence of God: A Work of Fiction,* that "the more sophisticated you are, the more annotated your mental life." How does your reading feed into your writing, and vice versa? Do you take notes as you read—on a laptop, on Post-its, in a notebook . . . ? Do you mark up your books, with pencil, pen, bookmarks, sticky notes . . . ? Or are there some categories in which you do (working materials, cookbooks . . .) and others that you wouldn't deface?

Sometimes I'm chasing after a rhythm in a sentence I'm writing, and I'll hear, vaguely, a rhythm from some other sentence, something I've read but can't immediately identify. That's how intimately my reading enters into me. I've got the rhythm of sentences stored away. I'd never expected to be a novelist. The field for which I was trained is philosophy of science. That's what my doctorate is in, and that's what I taught. But I've always loved novels, loved them with a passion I couldn't justify to myself, until it turned out that what I'd been preparing to be, all those years, sneaking those novels when I ought to have been boning up on journal articles, was a novelist. But I'm never aware, at the time of my reading, what's going to be useful. I simply read attentively. If a book doesn't capture my full attention, then it's not for me. I never take notes on novels. I'm living in them. The same goes for poetry. Philosophy books are entirely different. There I'm carrying on a dialogue with them, and I'll often jot my thoughts down in the margins. I feel a bit intimidated writing in leather-bound books, but otherwise I'll mark up anything.

In that novel, there's also a quip about a book as a "stepladder to enlightenment." Do you feel comfortable using books to sit on, to prop up other objects, to serve as a coaster under a glass?

Kant tells us that a person can never be used as a means to an end, but must be viewed as an end in itself. This is one of the formulations of his famous categorical imperative. Well, that pretty much summarizes my attitude toward books. I would *never* use a book as a coaster or to prop up something else, any more than I'd use a person toward that end. Well, maybe a phone book, but not a book that was authored, into which some suffering writer—and all writers suffer—poured her heart and soul.

Temperamentally, are you a pack rat or a toss rat? Do you store other kinds of media—cassette tapes, LPs, CDs— or do you download and discard? How do you dispose of the books you don't want—donating, recycling, putting out on the curb . . . ? Do you have some taboo against throwing away books when you're done reading them, or replacing books when they fall apart from wear and tear?

Because I've been a judge for quite a few book contests, including the National Book Award, which had us reading close to three hundred books that year, I do find myself in a position of forced disposal. But chances are if it's a book I actually chose to acquire, I'll never get rid of it. And that certainly includes any books that are falling apart from wear and tear. Sometimes, if the situation is dire, I'll buy a second copy. So, for example, my first copy of William James's *The Varieties of Religious Experience,* which I'd bought in high school with those babysitting earnings, is in tatters. I've bought a second copy, which I consult, but only so that the original copy is preserved.

Have you seen your own reading (or writing) habits change as the medium changes? Do you use an e-reader (Kindle, iPad, et cetera)?

I find all the hand-wringing about how the new media is diminishing our intellectual capacities unconvincing. For a researcher, these new ways of accessing information are just extraordinary.

I think it introduces the possibility of a new standard of cognitive exactness and precision. Some friend is making an argument, appealing to some dubious fact? Google is right at hand, to either verify or falsify.

Top Ten Books
Rebecca
Goldstein

Plato
The Collected
Dialogues

Isaac Bashevis
Singer
The Collected
Stories

Henry James
The Complete
Notebooks
of Henry James

Benedict de
Spinoza
The Ethics

Steven Pinker
How the Mind
Works

E. A. Burtt
The Metaphysical
Foundations of
Modern Physical
Science

George Eliot
Middlemarch

Thomas Nagel
The Possibility
of Altruism

David Hume
A Treatise of
Human Nature

William James
The Varieties of
Religious Experience

PLATO

The Collected Dialogues

including the Letters

edited by Edith Hamilton and Huntington Cairns

with Introduction and Prefatory Notes

Bollingen Series LXXI · Princeton

Isaac
Bashevis
Singer

Winner of the Nobel Prize for Literature

The
Collected
Stories

THE COMPLETE NOTEBOOKS OF HENRY JAMES

EDEL

POWERS

OXFORD

How
the
Mind
Works

STEVEN PINKER

AUTHOR OF *THE LANGUAGE INSTINCT*

The Metaphysical Foundations
of Modern Physical Science

E.A. Burtt

The scientific thinking of Copernicus, Galileo, Newton
and their contemporaries

MIDDLEMARCH
GEORGE ELIOT

Edited by BERT G. HORNBACK

A NORTON CRITICAL EDITION
SECOND EDITION

The
Possibility of
ALTRUISM

Thomas Nagel

William
James the varieties
of religious
experience

LEAH PRICE: How far back do your collections stretch? When were the first books that you still own acquired? At what age did you start buying books? Which ones have you kept, and shed, as you moved? Have there been periods of your life when you stopped reading?

STEVEN PINKER: I have some books going back to early adolescence, including *One Two Three...Infinity,* but I really started acquiring books when I graduated from high school and was awarded a ten-dollar gift certificate to a local bookstore. Ten dollars bought a lot of paperbacks in 1971, though you get what you pay for—many were printed on high-acid paper with glue bindings and are now disintegrating. I've been acquiring books ever since, though I am not squeamish about culling them. With every move (all eleven of them) or every three years, I scan my collection and give away the ones I know I will never open again. Even if I do make a mistake, it's cheaper to rebuy a book than to own or rent a large enough apartment to house every book I have ever bought.

Could you say something about the books you selected for our top ten? Which of your books are the most important to you? Which are the ones you would grab first if a fire broke out?

I am not sentimental about books as physical objects—I don't collect rare books, don't mourn lost ones (unless they have marginalia), and alternate between paper and pixels depending on what's convenient. I don't have to have my favorite books near me, and would not take even a minuscule chance with my safety to grab a book in a fire. But then a concentration on information over physical media has been a constant in my life. In my research as a cognitive scientist, I privilege cognitive information processing over neural hardware, and as a boy in Hebrew school I remember challenging a rabbi as to why the Torah had to be written out in vegetable ink on parchment—if the ideas were paramount, why not IBM punch cards?

I do love the *contents* of books, of course. A common denominator in many of my nonfiction choices is their combination of clarity, rigor, accessibility, depth, and wit. The novels by Twain and Melville are gold mines for anyone interested in language and in human nature.

The bookshelf, literally: what are your shelves made of? How did you acquire them?

My shelving consists of an enormous matrix of white cubes. I discovered the joy of cubes about fifteen years ago. They make it easy to categorize and find books, and they do away with the need for those awful things called bookends. In my old condo I had a closet factory install them; here I ordered them over the Internet and assembled them myself. I reordered new modules so often that someone at the company was curious how I was using them. When I sent in a photo and the salesperson recognized me from my books, he asked if they could use the photo on their website (http://www.smartfurniture.com/smartshelves. html), and if I'd be willing to host a camera crew from the TV show *I Want That* and do a testimonial. I believe in the product, so I did a hammy

sales pitch, which ended up on a new website that I was only dimly aware of at the time: YouTube.

Are there kinds of books you keep in places other than the bookshelf—cookbooks, phone books, pornography?

I own only one book that could be called pornographic: a French book of stereoscopic nude photos from the late nineteenth century (the heyday of stereophotography), bought when I wrote a section on stereo vision in *How the Mind Works*. It's my equivalent of buying *Playboy* for the interviews.

You wrote recently, in a rebuttal of Nicholas Carr's argument that digital media are making us stupider: "To encourage intellectual depth, don't rail at Power-Point or Google. It's not as if habits of deep reflection, thorough research, and rigorous reasoning ever came naturally to people. They must be acquired in special institutions, which we call universities, and maintained with constant upkeep, which we call analysis, criticism, and debate. They are not granted by propping a heavy encyclopedia on your lap, nor are they taken away by efficient access to information on the Internet." Have you seen your own reading (or writing) habits change as the medium changes? Do you use an e-reader (Kindle, iPad, et cetera)? Do you read books on your phone? How much do you read online? Do you buy or subscribe to newspapers in hard copy? Do you listen to audiobooks? Do you prefer reading aloud or being read aloud to?

I sometimes flip between reading a single book in iPhone, iPad, and paper incarnations, depending on where I am at the time. I love the way that the iPhone allows me to steal back snatches of wasted time and enjoy a book—standing in line to board a plane, or on a crowded subway platform. Though I have read the morning paper as an obligatory ritual every day since I was sixteen, I recently switched to the iPad, largely because home delivery is spotty downtown where I live, complicated further by my frequent travel. I used to read the newspaper with a scissors—now I e-mail articles to myself.

What do you imagine your library looking like five, ten, twenty years from now? Do you think you'll still own objects made of paper and glue?

Just as television didn't put an end to radio or the movies (to say nothing of books), I don't think e-books will put an end to hard copies, even for someone like me who loves technology and does not fetishize the physical medium of books. For many purposes paper is an excellent technology. For example, it allows you to use your own spatial memory as a guide to how to locate a book (which is often faster than electronic searching), how far along in a book you are, and where in the book you remember seeing a passage (when you can't remember a distinctive keyword).

Top Ten Books
Steven Pinker

Theodore M.
Bernstein
The Careful Writer:
A Modern Guide
to English Usage

Noam Chomsky
Reflections
on Language

Richard Dawkins
The Blind Watch-
maker: Why the
Evidence of
Evolution Reveals
a Universe
Without Design

Bernard DeVoto,
ed.
The Portable
Mark Twain

Galileo
Dialogue Concern-
ing the Two Chief
World Systems

George Gamow
One Two Three . . .
Infinity: Facts
and Speculations
of Science

Rebecca
Newberger
Goldstein
36 Arguments
for the Existence
of God: A
Work of Fiction

Thomas Hobbes
Leviathan

William James
Psychology

Isaac Bashevis
Singer
Enemies, A Love
Story

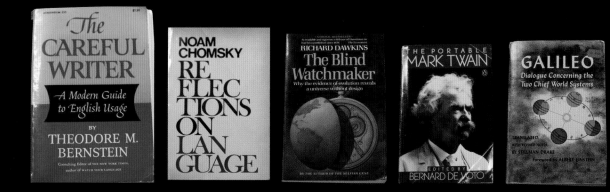

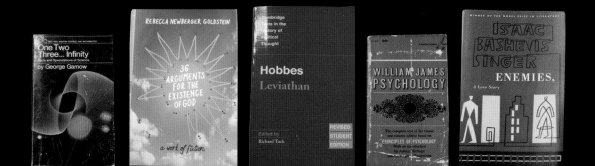

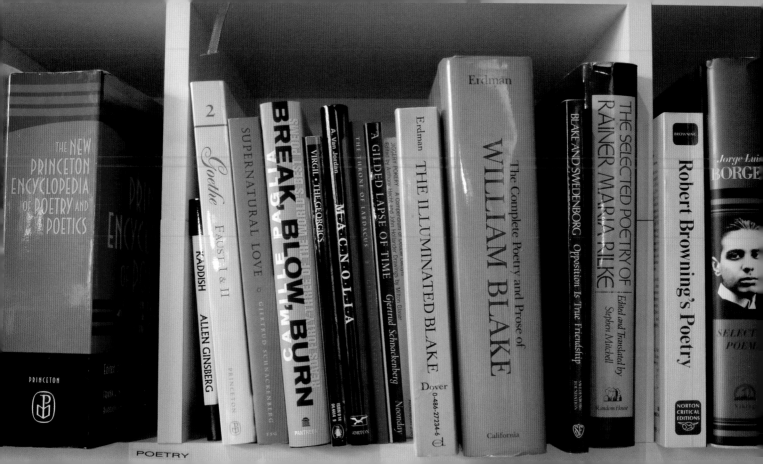

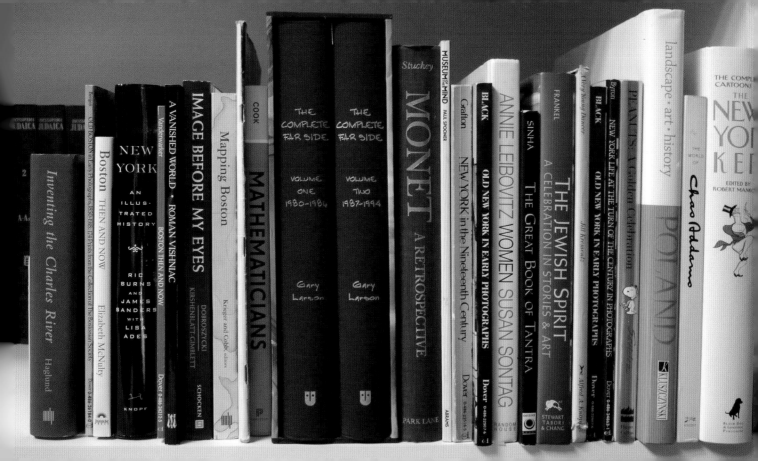

MEDIEVAL PHILOSOPHY

A Presocratics Reader

THE CONCEPT OF MATTER IN GREEK AND MEDIEVAL PHILOSOPHY | McMULLIN

REGINALD E. ALLEN

Greek Philosophy: Thales to Aristotle

Michael Wood

The Road to Delphi

AN INTRODUCTION TO EARLY GREEK PHILOSOPHY

An introduction to ANCIENT PHILOSOPHY by A. H. ARMSTRONG

Brumbaugh

The Philosophers of GREECE

SUNY

$1.25

$1.25

A HISTORY OF PHILOSOPHY

A HISTORY OF PHILOSOPHY

FREDERICK COPLESTON S.J.

VOL. 1 PART II IMAGE D 141 B

A HISTORY OF PHILOSOPHY GREECE & ROME

FREDERICK COPLESTON S.J.

VOL. 1 PART II IMAGE D134 B

$1.75

Grep Legum N Vol Bacon & Rome

Grep Legum N

A HISTORY OF PHILOSOPHY

Modern Philosophy: Descartes to Leibniz

FREDERICK COPLESTON S.J.

VOLUME 4

IMAGE D 17

95¢

A HISTORY OF PHILOSOPHY

Modern Philosophy

FREDERICK COPLESTON S.J.

VOL. 7 Part I IMAGE D 140 A

95¢

A HISTORY OF PHILOSOPHY

Modern Philosophy

FREDERICK COPLESTON S.J.

VOL. 8 Part I IMAGE D139A

$1.25

A HISTORY OF PHILOSOPHY Kant

FREDERICK COPLESTON S.J.

VOL. 6 Part II IMAGE D13

A History of Western Philosophy

Bertrand Russell

TOUCHSTONE

NAILS

PLATO *Protagoras and Meno*

PENGUIN CLASSICS

THE PEOPLE OF PLATO

HACKETT

0364

IRIS MURDOCH

THE FIRE AND THE SUN

VIKING

HACKETT

0126

University of Notre Dame Press

Fp

BEACON PRESS

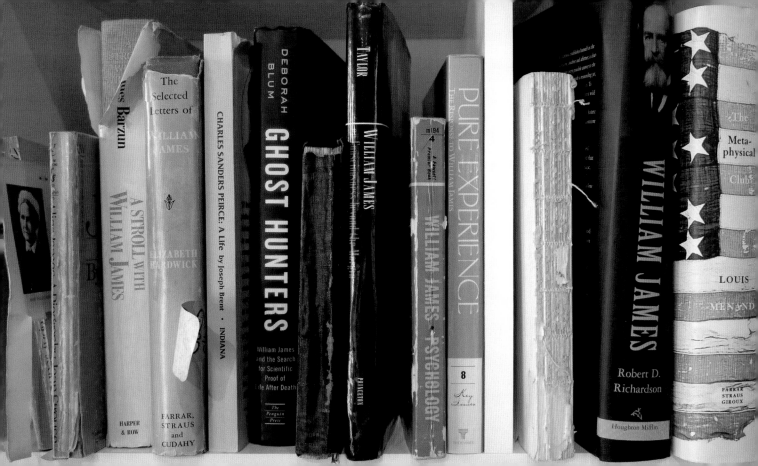

A STROLL WITH WILLIAM JAMES

James Barzun

The Selected Letters of WILLIAM JAMES

ELIZABETH HARDWICK

HARPER & ROW

FARRAR, STRAUS and CUDAHY

CHARLES SANDERS PEIRCE: A Life by Joseph Brent · INDIANA

DEBORAH BLUM

GHOST HUNTERS

William James and the Search for Scientific Proof of Life After Death

The Penguin Press

TAYLOR

WILLIAM JAMES

PRINCETON

E 194 4

A Fawcett Premier Book

WILLIAM JAMES · PSYCHOLOGY

8 Key Issues

PURE EXPERIENCE

THE RESPONSE TO WILLIAM JAMES

WILLIAM JAMES

Robert D. Richardson

Houghton Mifflin

The Meta-physical Club

LOUIS MENAND

FARRAR STRAUS GIROUX

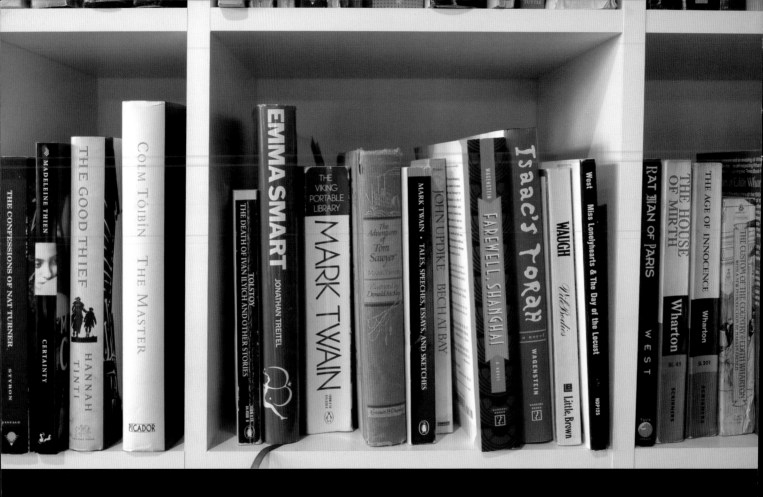

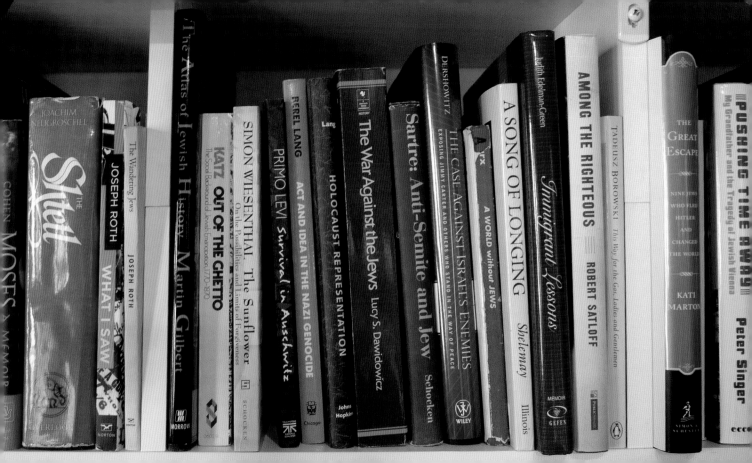

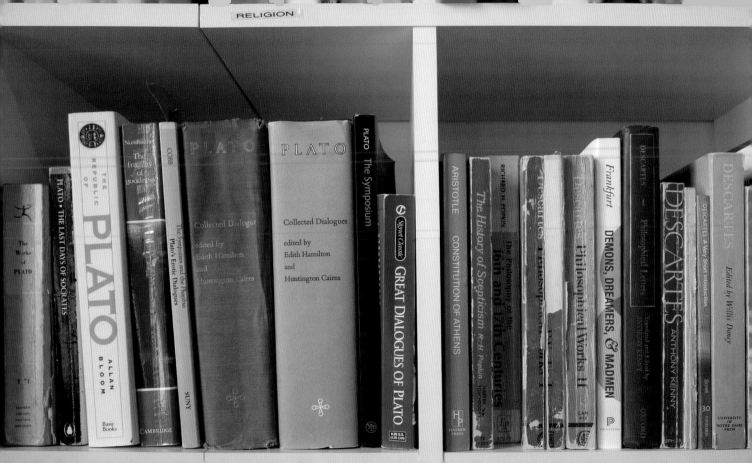

The Works of PLATO

PLATO • THE LAST DAYS OF SOCRATES

THE REPUBLIC OF PLATO
ALLAN BLOOM
Basic Books

Nussbaum
The fragility of goodness
CAMBRIDGE

COBB
The Symposium and the Phaedrus
Plato's Erotic Dialogues
SUNY

PLATO
Collected Dialogues
edited by
Edith Hamilton
and
Huntington Cairns

PLATO
Collected Dialogues
edited by
Edith Hamilton
and
Huntington Cairns

PLATO
The Symposium

Signet Classic
GREAT DIALOGUES OF PLATO
6.95 U.S.
(1.99 CAN)

ARISTOTLE
CONSTITUTION OF ATHENS
HAFNER PRESS

The History of Scepticism
R H Popkin
HARPER TORCHBOOKS

RICHARD H. POPKIN
The Philosophy of the 16th and 17th Centuries

Descartes
Philosophical Works I

Descartes
Philosophical Works II
CAM

Frankfurt
DEMONS, DREAMERS, & MADMEN
PRINCETON

DESCARTES —
Philosophical Letters
Translated and Edited by
ANTHONY KENNY
OXFORD

DESCARTES
ANTHONY KENNY

DESCARTES A Very Short Introduction

DESCARTES
Edited by Willis Doney
UNIVERSITY OF NOTRE DAME PRESS

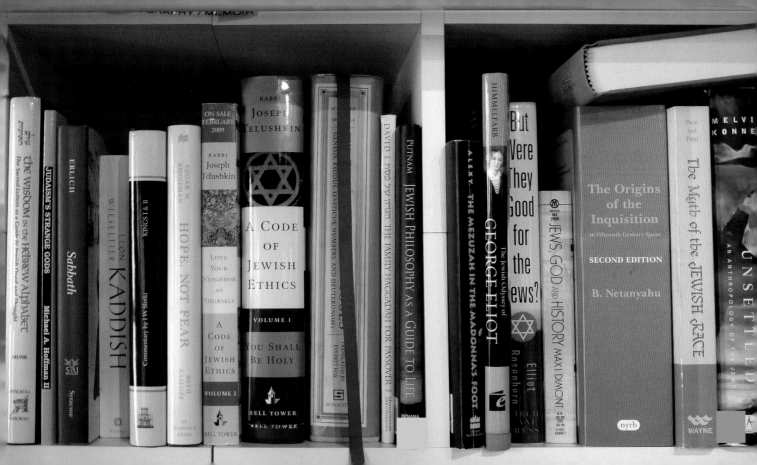

the WISDOM in the HEBREW ALPHABET — The Sacred Letters as a Guide to Jewish Deed and Thought — MUNK — ARTSCROLL / MESORAH

JUDAISM'S STRANGE GODS — Michael A. Hoffman II

ERLICH — Sabbath — Syracuse

Leon Wieseltier — KADDISH — Vintage

KINGS I & II — Commentary by I M Slotki

Edgar M. Bronfman — HOPE, NOT FEAR — BETH ZASLOFF — ST MARTIN'S PRESS

ON SALE FEBRUARY 2009 — RABBI Joseph Telushkin — LOVE YOUR NEIGHBOR AS YOURSELF — A CODE OF JEWISH ETHICS — VOLUME 2 — BELL TOWER

RABBI JOSEPH Telushkin — A CODE OF JEWISH ETHICS — VOLUME 1 — YOU SHALL BE HOLY — BELL TOWER

GENESIS, EXODUS, LEVITICUS, NUMBERS, AND DEUTERONOMY — TRANSLATED BY EVERETT FOX — SCHOCKEN

DAVID — THE FAMILY HAGGADAH FOR PASSOVER

PUTNAM — JEWISH PHILOSOPHY AS A GUIDE TO LIFE — INDIANA

ALEXY — THE MEZUZAH IN THE MADONNA'S FOOT — HarperSanFrancisco

HIMMELFARB — The Jewish Odyssey of GEORGE ELIOT — Encounter

But Were They Good for the Jews? — Elliot Rosenberg — MENTOR ME 2866 — U.S. $5.99 CAN $8.99 — 0-451-62866-7

JEWS, GOD AND HISTORY — MAX I DIMONT

The Origins of the Inquisition in Fifteenth Century Spain — SECOND EDITION — B. Netanyahu — nyrb

Patai and Patai — The Myth of the JEWISH RACE — WAYNE

MELVIN KONNER — UNSETTLED — AN ANTHROPOLOGY OF THE JEWS

Lev Grossman
& Sophie Gee

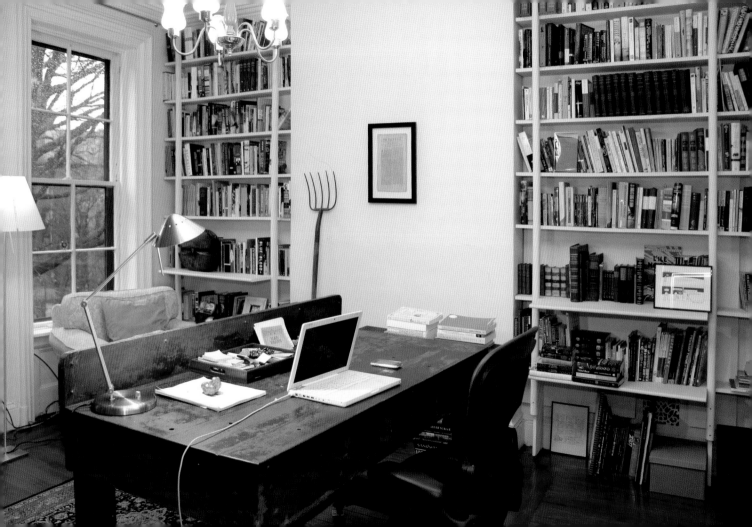

LEAH PRICE: In interviews, you've referred to libraries as maps of the brain; what exactly do you mean by this?

LEV GROSSMAN: I didn't mean anything especially profound. Just that when you look around somebody's personal library, you can actually see, physically, instantiated as objects, a map of that person's interests and preoccupations and memories. When you stand inside somebody's library, you get a powerful sense of who they are, and not just who they are now but who they've been. My library contains old books, books from college courses, books from now-abandoned careers and relationships, books from my father's library . . .

It's not very practically useful as a map, since most libraries are organized around a totally arbitrary scheme, namely the alphabet—but still. It's a wonderful thing to have in a house. It's something I worry is endangered by the rise of the e-book. When you turn off an e-book, there's no map. All that's left behind is a chunk of gray plastic.

How far back does your collection stretch? When were the first books that you still own acquired? At what age did you start buying books? Which ones have you kept, and shed, as you moved? At what phases of your existence has reading books—and owning books—been most important to you? Have there been periods of your life when you stopped reading?

In terms of my deep personal history, it's not a particularly impressive collection. I recognize a couple of fantasy novels that go back to early junior high—*The Once and Future King,* by T. H. White, and some Fritz Leiber. *The Chronicles of Narnia* go back to when I was seven or eight. But even those books aren't my old original copies. I lost all my original childhood books, or my other siblings made off with them. I'm not sentimental about them. Or really about anything from my childhood.

That said, since I left college, books have been the one thing, the one class of object, that I've assiduously hung on to, through literally dozens and dozens of apartments. The idea of needing a book and not having it immediately to hand is strangely horrifying to me.

Could you say something about the books you selected for our top ten?

I'll just pick out a couple.

One is a three-volume set of Cicero that belonged to my father. They're extraordinary objects: late sixteenth century, I forget the exact year, but printed by the Aldine Press, an innovative Venetian press that is justly renowned for, among other things, having invented italics. At some point this particular set was in the Vatican Library, but they must have been decommissioned and somehow they found their way to a used book store in Chicago, where my father bought them for ten dollars when he was a student and needed a cheap copy of Cicero. The market for old books wasn't as frantic then as it is now.

The other book I should mention is a beautiful first edition of C. S. Lewis's *The Magician's Nephew,* a book that was one of my earliest and most intense

reading experiences. It's influenced a lot of my fiction. This particular copy was a terrifyingly extravagant gift from a friend, who really shouldn't have. But it's not the sort of gift you can refuse. If a fire broke out, I would grab it first. Partly because I suspect it of having magical properties that would be useful in an emergency.

The bookshelf, literally: what are your shelves made of? How did you acquire them?

Some of them were built into the walls when we bought this house. Others were custom-built, but not for this apartment. They belonged to the apartment I lived in with my ex-wife (who is herself a rare-books dealer) before we were divorced about five years ago. Funny how libraries retain ghostly impressions of the past—those bookshelves retain the dimensions of those old rooms, not of the rooms they're currently in, so they're slightly ill-fitting. I hate them. I can't wait to have them replaced.

Are your and Sophie's libraries separate or interfiled? What do you do about duplicates? How do you arrange, or attempt to arrange, your books? How do you know how to find them on the shelf, if indeed you do know? (Alphabetical order, subject, size, chance . . . ?) Does this resemble the way you arrange (or don't) your other possessions?

Our collections are completely intermingled. Well, not completely—Sophie keeps a small autonomous collection in her office at Princeton. But I think that was a crucial moment in our relationship. Once we merged our books, we knew there was no going back. We threw out the duplicates when we did it—though again, not quite completely. When you're tossing duplicates, the question is whose copy gets tossed, and in a couple of cases neither of us backed down. There are a suspicious number of redundant *Brideshead Revisited*s in our collection. Also *Mrs. Dalloway*s. There's a lot of Jane Austen.

The books are arranged alphabetically, with the usual exceptions. Oversized ones, or very old ones, are kept by themselves. Also my comic books.

Also none of the books are arranged alphabetically within their letter. I think a little randomness is a good thing in a library. It encourages serendipity.

I will add that I'm adamant about not segregating science fiction and fantasy and other genre fiction from the literary stuff. Sophie and I both take genre fiction very seriously, and we don't really think of it differently from literary fiction. It's part of our house literary ideology. And it creates interesting juxtapositions. Vladimir Nabokov and Larry Niven. Iain Banks and Samuel Beckett. Pullman and Pope. Helen Fielding and Henry Fielding.

What books are not on the shelves you allowed us to photograph? Are there kinds of books you keep in places other than the bookshelf—cookbooks, phone books, pornography?

All my daughter's books are in her room. A very few books are hesitantly starting to migrate from our library to hers. Even the baby has a few of her own books.

Oh, and there are our own books, the ones Sophie and I wrote. It feels a little odd to have my books on my own shelf, as if there were some conceivable circumstance under which I would take them down and peruse them, just for the sheer pleasure of it. Totally unimaginable. There's a crypt in the basement where foreign translations of our books dwell. I doubt I'll ever want to consult the Croatian translation of *The Magicians,* but I couldn't quite bring myself to throw it away.

What proportion of the books that you read do you own—and what proportion of the books that you own have you read? Do you lend your own books to friends?

I would say that I've read a pretty high proportion of the books I own. I don't like to keep books that I've never read and know, for a fact, that I'll never get around to reading. You want a library to have some integrity. Every book should pull its weight. Sometimes I'll spot a straggler, something I bought on a misguided impulse, and I'll tweeze it out like a stray hair.

The one exception being books with sentimental value, which they have to have pretty major sentimental value to be kept around if I don't read them. But for example, my father's complete edition of *The Golden Bough*—not the condensed version, but the one that runs to a dozen volumes, including one whole volume for the bibliography and the index. Totally unreadable, but I can't part with it. The same with his complete Joseph Conrad. My father and I aren't especially close, but he lived to read— I suppose that's partly why we weren't that close. I'm talking about him in the past tense, though he's still alive. He's in the late stages of Alzheimer's and can't read anymore. When my parents moved out of the house where I grew up, my mother sold off his library—it was like they were breaking up his brain, the same way the Alzheimer's was doing. I couldn't take the whole thing, but I rescued a few volumes.

How does your reading feed into your writing, and vice versa? Are there genres that you think of as "pleasure reading"—unproductive, unusable? Do you take notes as you read—on a laptop, on Post-its, in a notebook . . . ?

Do you mark up your books, with pencil, pen, bookmarks, sticky notes . . . ? Or are there some categories in which you do (working materials, cookbooks . . .) and others that you wouldn't deface?

I read obsessively when I'm writing. I think there are two kinds of fiction writers, those who read incessantly while they write and those who can't read at all, lest their individual voices get overwhelmed, or tainted somehow. I'm the first kind. To use a painfully precious metaphor, I need fixed stars to navigate by, otherwise I get lost in the blankness of the page.

I take a lot of notes, usually in the books themselves. It's another thing I'm not sentimental about. I'm a professional book reviewer, so I've scribbled over a lot of books that would probably one day have been valuable first editions.

Temperamentally, are you a pack rat or a toss rat? Do you store other kinds of media—cassette tapes, LPs, CDs—or do you download and discard? How do you dispose of the books you don't want—donating, recycling,

putting out on the curb . . . ? Do you have any taboo against throwing away books when you're done reading them, or replacing books when they fall apart from wear and tear?

I'm not a pack rat. I love to denude myself of possessions. Books are the only exceptions. I hate to discard a book, though I've hardened myself to it. A lot of bad books get published, and a lot of them pass through my hands, and you can't show them mercy or they'll follow you around for the rest of your life, taking up priceless shelf space. I put them out on the curb. Then I watch cattily to see how long it takes for somebody to pick them up.

What do you imagine your library looking like five, ten, twenty years from now? Do you think you'll still own objects made of paper and glue? And—with apologies for a morbid question—do you ever think about what will happen to your library after your death? More cheerfully: you mentioned that you are beginning a library for your new daughter. Are you confident that by the time she's old enough to read, books will still be relevant?

Really, I imagine my library looking much the same as it does now, except that I'll be rid of my damn divorce bookcases, and I'll have built a lot of new shelves. Right now the tail end of my library, the W, X, Y, and Z's, are still in boxes. I don't think much about what will happen to my library when I die. I suppose the books will wander around and then perish the way everything else does, except the really expensive books, which I imagine that somebody responsible will collect.

I do hope my daughters will keep some of my books, the way I have with my father's books. A few of my books have already migrated from our collection to my older daughter's, which I think is a good sign. My father didn't have any of his parents' books, which is a bit sad, and I wouldn't like to see that state of affairs repeated. My father's father was a car salesman and not a books person at all. The only things I have of his are a couple of embroidered bar towels. Which are, admittedly, very nice bar towels.

Top Ten Books
Lev Grossman

Evelyn Waugh
Brideshead
Revisited

Aldus Manutius
Cicero

Douglas
Hofstadter
Gödel, Escher,
Bach: An Eternal
Golden Braid

C. S. Lewis
The Lion, the Witch,
and the Wardrobe

C. S. Lewis
The Magician's
Nephew

Virginia Woolf
Mrs. Dalloway

Deirdre Bair
Samuel Beckett

Sophie Gee
The Scandal
of the Season

T. H. White
The Sword
in the Stone

Alan Moore
Watchmen

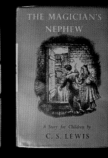

An Interview with
Sophie Gee

LEAH PRICE: How far back does your collection stretch? When were the first books that you still own acquired? At what age did you start buying books? Which ones have you kept, and shed, as you moved? At what phases of your existence has reading books—and owning books—been most important to you? Have there been periods of your life when you stopped reading?

SOPHIE GEE: My collection goes back to when I was a child. I still have my *Ant and Bee* books, now sadly out of print and almost impossible to obtain. Many of my childhood books are still in storage in Australia, and one of the lovely things about having this big house and moving somewhere permanently is that I'll be able to unpack my library. . . . The first grown-up book I acquired was *Pride and Prejudice,* a red clothbound copy given to me by my parents on my twelfth birthday. I started buying books as a teenager, with book vouchers given to me for Christmas and birthdays. I've shed a lot of contemporary fiction over the years and kept all the "classics"—the books that have been prescreened by time. Reading and owning books was probably

most important to me as a child; they were the possessions that meant the most to me and that defined my private child's world most completely. I think the other very important period of buying books was when I started building a new, adult library as a graduate student and junior professor. It represented my investment in my adult intellectual life, and in being in America, since books are hard to transport and therefore signs of permanence.

Could you say something about the books you selected for our top ten? Which of your books are the most important to you? Which are the ones you miss the most when you're away from home? Which are the ones you would grab first if a fire broke out? Why?

Emma and *Pride and Prejudice* are my first-place-tied sentimental favorite books. I picked *Emma* for this list because, of the two, it's the one I find most satisfying as a scholar and critic as well as a fan. The edition I chose is dear to me (the Oxford edition edited by Chapman) because I won it as a prize for being top of my class in English at high school. It

was a distinction that meant a great deal to me at the time, and gave me the confidence to keep reading and writing as avidly as I wanted to.

I chose *Middlemarch* for similar reasons to *Emma*—as a novel of provincial life it is indebted to and builds upon Austen's "village" settings in very interesting ways.

Paradise Lost is the other major world classic on my list. It's the text that makes me feel most indebted to my education. I could barely have read Milton's poem without doing a Ph.D. in English, let alone understood it and enjoyed it in the ways that I am now able to.

The other choices are more personal and idiosyncratic. I chose "The Rape of the Lock" because it inspired my first novel, *The Scandal of the Season*— and because it's a short masterpiece that establishes the comedy of manners as one of the most important modes in English writing (a mode that Jane Austen was to perfect a hundred years later). T. H. White and Rudyard Kipling are childhood favorites—*Stalky and Co.* is a boarding school story that absorbed me when I was still oblivious of Kipling's problematic

politics, and T. H. White is the greatest modern Arthurian retelling—also important because Lev and I are equally passionate about it. Pym's *Excellent Women* is one of the unsung small masterpieces of twentieth-century English writing, and Larkin's prose collection *Required Writing* is enormously enjoyable and instructive for would-be prose writers. Evelyn Waugh and Kingsley Amis continue my interest in funny writing. If it were a top eleven list, I would have chosen Lev's new novel *The Magician King* because Lev is a wonderful writer, from whom I have learned an enormous amount about my own craft. *The Magician King* is the first of his books to be written entirely during our life together, and as we have talked about it and worked on it together, we have got to know each other in ways that wouldn't have been possible without sharing our writing. Especially in the early draft stage, when one is so vulnerable, but also when the pure ideas and impulses are still so vividly visible.

As someone who writes both fiction and criticism, each informed by the other, do you find that you read and/ or handle books of fiction and books of criticism differently? Do you annotate one more than the other, own one and borrow the other from the library, treat one with more respect or affection than the other? Do you keep one in the office, the other at home?

Yes, I guess criticism lives at the office, except for a few books that I like to have around. I moved around a lot before I met Lev and settled down in Brooklyn, so a lot of my fiction books are in the office at Princeton too, because I needed a place for them to be housed permanently while I was housed so impermanently.

Are your and Lev's libraries separate or interfiled? What do you do about duplicates?

We've merged our libraries to a great extent, but mostly we each know whose books started out as whose, because we have memories of being the book's reader, why we kept it, what was important about the time and the way in which we read it. We each have quite a romantic relationship to books in that way.

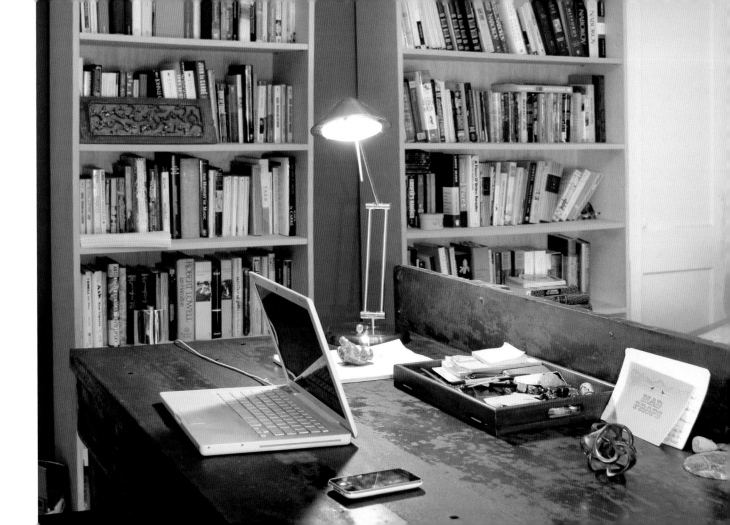

What books are not on the shelves you allowed us to photograph? What books do you keep in the kitchen, in the bathroom, on the bedside table?

This is a great and important question for me (and I think Lev), because our cookbooks aren't on the bookshelves you photographed but they are intensely important to us. I could happily do a top ten cookbooks list. In fact, we pretty much have one, because there's a shelf in our kitchen right above the stove where we keep the most used cookbooks, and those are the staples. Cooking is a very important part of my life with Lev and also my transnational life with my sister Harriet. We tell each other what we cook each week, exchange recipes, even photos of our cooking.

What proportion of the books that you read do you own, and vice versa?

I used to have a rule that I would only put books on my shelves when I had read them, or significant parts of them. There was a nice period in graduate school when this was true and I had a very intense, intimate relationship with my bookshelves as a result. More recently I've enjoyed having some books on my shelves that I have not yet read but which strike me as books that I should own, and one day read. Ariosto's *Orlando Furioso,* for example. Heidegger's *Being and Time* (I'm not ever going to read that, am I? I should admit it now . . .).

Temperamentally, are you a pack rat or a toss rat? Do you store other kinds of media—cassette tapes, LPs, CDs—or do you download and discard? How do you dispose of the books you don't want—donating, recycling, putting out on the curb . . . ? Do you have any taboo against throwing away books when you're done reading them, or replacing books when they fall apart from wear and tear?

I'm a bit of both. I get very, very attached to certain things, but I have a strong purgative (purgatorial?) impulse, and I don't like having things around that aren't important to me in some way. A lot of books come though our house, and a lot go out again. We

had a phase of taking boxes of books to the Strand bookstore when we were first moving in together and we did a big cull of our book collections. But now we put unwanted books out on the stoop, and invariably they are gone within hours. I'm curious to know who ended up with the coffee table book about ecofriendly cleaning products, and what they're doing with it now.

Top Ten Books
Sophie Gee

Rudyard Kipling
*The Complete
Stalky and Co.*

Evelyn Waugh
*Decline and Fall
Handful of Dust*

Jane Austen
Emma

Barbara Pym
Excellent Women

Kingsley Amis
Lucky Jim

George Eliot
Middlemarch

T. H. White
*The Once and
Future King*

John Milton
Paradise Lost

Alexander Pope
*The Rape
of the Lock*

Philip Larkin
*Required Writing:
Miscellaneous
Pieces, 1955–1982*

WORLD'S CLASSICS

RUDYARD KIPLING
THE COMPLETE
STALKY & CO.

A
HANDFUL
OF DUST

EVELYN
WAUGH

DECLINE
AND FALL

A Laurel Edition

The Oxford Illustrated
Jane Austen

EMMA

PENGUIN CLASSICS

BARBARA PYM
Excellent Women

Introduction by A. N. Wilson

KINGSLEY AMIS
Lucky Jim

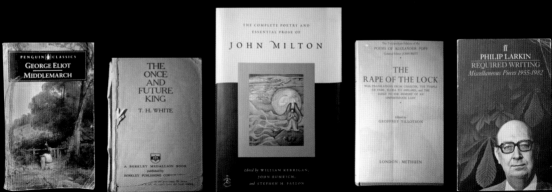

PENGUIN CLASSICS

GEORGE ELIOT
MIDDLEMARCH

THE
ONCE
AND
FUTURE
KING

T. H. WHITE

A BERKLEY MEDALLION BOOK
published by
BERKLEY PUBLISHING CORPORATION

THE COMPLETE POETRY AND
ESSENTIAL PROSE OF

JOHN MILTON

Edited by WILLIAM KERRIGAN,
JOHN RUMRICH,
and STEPHEN M. FALLON

The Twickenham Edition of the
POEMS OF ALEXANDER POPE
General Editor JOHN BUTT

THE
RAPE OF THE LOCK

With Translations from Chaucer, the Temple
of Fame, Eloisa to Abelard, and the
Elegy to the Memory of an
Unfortunate Lady

Edited by
GEOFFREY TILLOTSON

LONDON: METHUEN

PHILIP LARKIN
REQUIRED WRITING
Miscellaneous Pieces 1955-1982

GUN.

WITH OCCASIONAL MUSIC

JONATHAN LETHEM

The Fortress of Solitude

JONATHAN LETHEM

The History of Magic
by
ELIPHAS LEVI

A.E. WAITE

LEVI

THE HISTORY OF MAGIC

Michael Lewis

PRINCE CASPIAN

The Return to Narnia

by C. S. LEWIS

LIAR'S POKER

C.S. LEWIS ②

PRINCE CASPIAN

C.S. LEWIS ⑥

THE MAGICIANS NEPHEW

C.S. LEWIS ⑦

THE LAST BATTLE

C.S. LEWIS ⑤

THE HORSE AND HIS BOY

C.S. LEWIS ④

THE SILVER CHAIR

WYNDHAM LEWIS

TARR

THE 1918 VERSION

BLACK SPARROW PRESS

LERMONTOV

A Hero of Our Time

Ardis

TOR

DOUBLEDAY

WEISER

ISBN 0-14-...

BLES

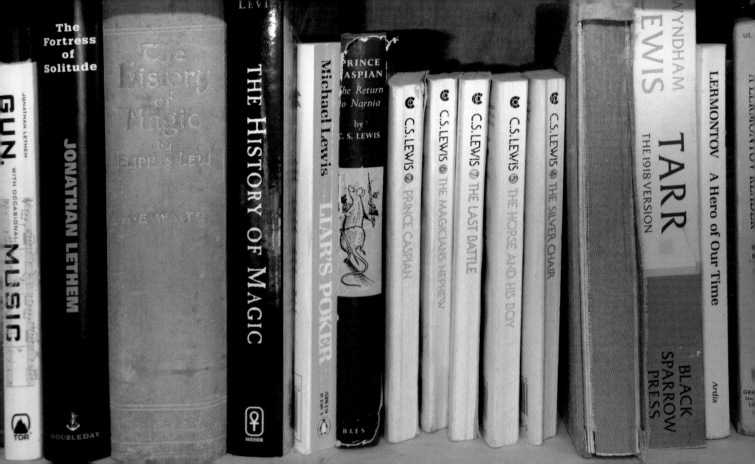

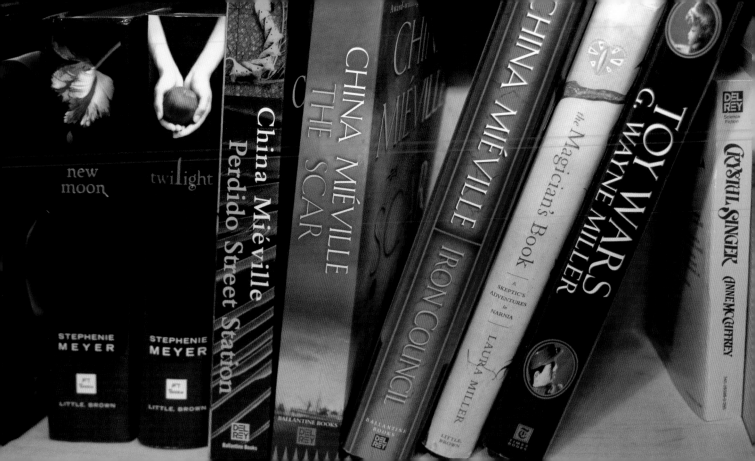

new
moon

twilight

STEPHENIE
MEYER

STEPHENIE
MEYER

LITTLE, BROWN

LITTLE, BROWN

China Miéville
Perdido Street Station

DEL
REY

CHINA MIÉVILLE
THE SCAR

CHINA
MIÉVILLE

BALLANTINE BOOKS

DEL
REY

CHINA MIÉVILLE

IRON COUNCIL

BALLANTINE
BOOKS

the Magician's Book

A
SKEPTIC'S
ADVENTURES
in
NARNIA

LAURA
MILLER

LITTLE
BROWN

TOY WARS
G. WAYNE MILLER

TIMES
BOOKS

CRYSTAL SINGER

ANNE McCAFFREY

DEL
REY
Science Fiction

THE
HEMINGWAY
READER

SCRIBNERS

NEXT

JAMES HYNES

REAGAN
ARTHUR
LITTLE,
BROWN

god is not Great
How Religion Poisons Everything
Christopher Hitchens

Life in Lexington 1946-1995
by Alice Hinkle and Andrea Cleghorn

METAMAGICAL THEMAS

DOUGLAS R. HOFSTADTER

Basic Books

SMILLA'S SENSE OF SNOW

FSG

MICHEL HOUELLEBECQ

H·P LOVECRAFT: AGAINST THE WORLD, AGAINST LIFE

SCRIBNER

Ernest Hemingway

A Moveable Feast

HOMER

THE
ODYSSEY

EVERYMAN'S
LIBRARY

HOMER

THE ILIAD

EVERYMAN'S
LIBRARY

THE ILIAD
Translated by Robert Fitzgerald

HOMER

PENGUIN
BOOKS

THE ILIAD

ROBERT FAGLES
BERNARD KNOX

HOMER

ISBN 0-14
02.7536 3

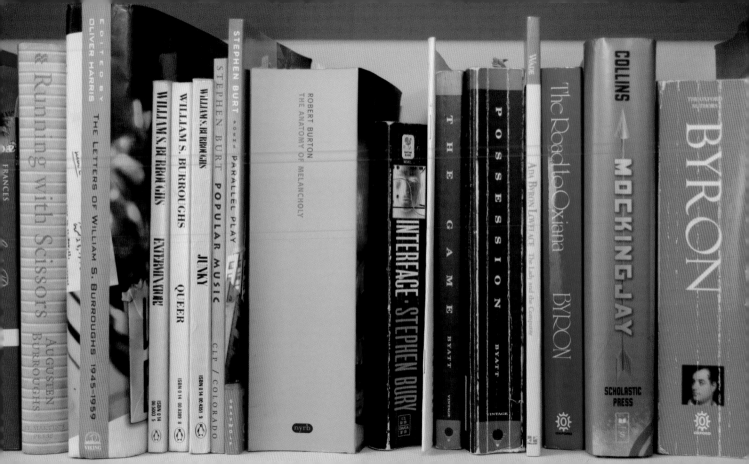

ANY HUMAN HEART · WILLIAM BOYD

THE AWARD-NOMINATED STORIES OF MICHAEL A. BURSTEIN

I REMEMBER THE FUTURE

THE LETTERS OF SAMUEL BECKETT 1929–1940

BALZAC · PÈRE GORIOT

BALZAC · SELECTED SHORT STORIES

THE BUSINESS · Iain Banks

EXCESSION · Iain M. Banks

CONSIDER PHLEBAS · Iain M. Banks

IAIN M. BANKS · LOOK TO WINDWARD

IAIN M. BANKS · THE PLAYER OF GAMES

IAIN M. BANKS · INVERSIONS

IAIN M. BANKS · AGAINST A DARK BACKGROUND

Jonathan Lethem

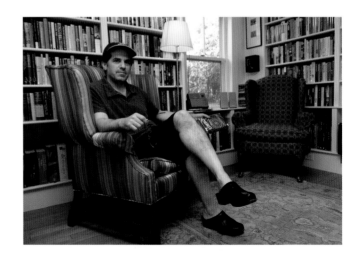

LEAH PRICE: How far back does your collection stretch?

JONATHAN LETHEM: I guess I remember books in my room as early as I remember my room. At least two of those are still with me: my mother's *Alice in Wonderland and Through the Looking Glass,* a beaten-up wartime edition in yellow boards, but with a lavish interior—the Tenniel illustrations each given their own page and framed with a red border, which still seems the only right way to view them, for me. And, a translation of a morose French children's classic, *Sans Famille* (translated as *Nobody's Boy*), about an orphan boy who picks up some dogs and a monkey on the road and becomes a street musician. Then the dogs die, one by one.

I started haunting used bookshops when I was twelve or thirteen. There were loads of good ones even in downtown Brooklyn, nice old moldering places run by bitter book veterans, who remembered better days that may or may not have existed, or foolish optimistic gambits by eager young men, like Second Hand Prose on Flatbush Avenue,

or Brazen Head on Atlantic, where at fourteen I apprenticed myself and made a lifelong friend in the eager foolish young man, Michael Seidenberg, as well as forging a career as an antiquarian bookseller—the only career, I like to say, I ever had before authoring. From the very beginning I took home as much of my pay in books as in pay.

Could you say something about the books you selected for our top ten?

I picked books I thought were lovely, strange, and unexpected. Which three words pretty well encapsulates what I hope to find when I open any book, as well as gaze at its outsides. This superficial way in is often fateful for me, in my life as a book hunter—something beautiful and peculiar lures me, and my brain, and my tastes, my writing life, my sense of what's possible, is changed by the contents of the book.

Others here are books I haven't read yet, but hope to (I won't say which ones). People sometimes act as though owning books you haven't read constitutes a charade or pretense, but for me, there's a lovely mystery and pregnancy about a book that hasn't given itself over to you yet—sometimes I'm the most inspired by imagining what the contents of an unread book might be.

Several of these—*Guide for the Undehemorrhoided, Rock and Roll Will Stand*—are the kind of books you might not know even if you thought you knew the particular author's work well. The author's secret books, the oeuvre behind the oeuvre. I'm obviously dedicated to things that are out-of-print, left-field, dubious. I like an air of privacy between me and a book, and often feel more comfortable with the lesser-known author, or the well-known author's lesser-known book. If I'm reading *Ulysses* or *Moby-Dick*, I'll resort to an unusual-looking edition.

The bookshelf, literally: what are your shelves made of? How did you acquire them?

I'm a terrible aesthetic reactionary now when it comes to shelves; the only shelves, I'm tempted

to say, are built-in shelves. I commissioned those that you photographed, the culmination of a life-long materialist dream or fetish. They're glossily painted wooden shelves, made to match the wood-work in a 150-year-old farmhouse. Or I'd ratify glass-fronted stacking cabinets, but I haven't been able to afford to lay in a room full of those. I must be seeking security in my old age. When I was a kid my shelves were tottering Rube Goldberg structures, made of bricks, milk crates, other books, and salvaged scraps of lumber from my father's carpentry shop.

How do you arrange, or attempt to arrange, your books? How do you know how to find them on the shelf, if indeed you do know? Does this resemble the way you arrange (or don't) your music?

My books are always organized, arranged, and always being rearranged, too—a constant process. I tend to oscillate between alphabetical absolut-ism and imperatives of genre, subject, size, color, publisher—I don't, for instance, ever like to see pocket-sized paperbacks with anything larger, and certain publishers have created spines so irresist-ibly lovely together that I've devoted sections to them, even when it busts authors I've got shelved elsewhere out of their alphabetical jail. And with the film and music books, I'm dedicated to clusters by subject—Orson Welles, say—alternating with clusters of favorite critics—James Naremore, say—who've often written on other directors who rate clusters of their own. So I end up with weird bridging continuums, like Welles/Naremore/Kubrick, or Dylan/Greil Marcus/Elvis/Peter Guralnick/Memphis soul.

Music is chaos, or strictly alphabetical, never anything in between. Chaos these days. Music also presents alphabetical problems you never encounter with books: where do you file LL Cool J? MC 900 Ft. Jesus? How about Little Walter? Does he go next to Big Walter, or nine letters away?

What proportion of the books that you read do you own? Do you lend your own books to friends?

I've got a lot of books I've never read—books I find charged and beautiful to pick up and consider, and might read some day, others I find charged and beautiful and wouldn't ever bother. Extra copies of books I love in variant editions. Reading copies of books I've got in precious editions. I hate lending, or borrowing—if you want me to read a book, tell me about it, or buy me a copy outright. Your loaned edition sits in my house like a real grievance. And in lieu of lending books, I buy extra copies of those I want to give away, which gives me the added pleasure of buying books I love again and again.

Do you listen to audiobooks? Do you prefer reading aloud or being read aloud to?

Never have been able to do this. I like reading aloud to a child, or to a crowd in an auditorium (the right one, not just any), but apart from one or two stray and lovely moments with a lover, have never much sat still for being read to. I'm a hypocrite—I hate attending readings.

What do you imagine your library looking like five, ten, twenty years from now? Do you think you'll still own objects made of paper and glue? And—with apologies for a morbid question—do you ever think about what will happen to your library after your death?

I'm almost fifty, and I doubt my library's going to change its nature much again at this point, just grow and shrink and get tinkered with like an old car. I do think about where they'll go after I die, constantly. I have an idea that I'll create a marvelous specific annotated catalogue, indicating hundreds if not thousands of exact destinations for individual volumes or minicollections within the whole—but the odds are probably pretty poor that I'll get to that, don't you think?

**Top Ten Books
Jonathan Lethem**

Flann O'Brien
At Swim-Two-Birds

Colin MacInnes
City of Spades

Charles Willeford
Cockfighter

Margaret Millar
The Fiend

Christina Stead
For Love Alone

Charles Willeford
A *Guide for the
Undehemorrhoided*

Vladimir Nabokov
Lolita

Wilson Tucker
*The Long Loud
Silence*

Greil Marcus, ed.
*Rock and Roll
Will Stand*

Elias Canetti
The Tower of Babel

FLANN O'BRIEN

At SWIM
·TWO·
Birds

"A BOOK IN A THOUSAND...
IN THE LINE OF ULYSSES
AND TRISTRAM SHANDY"
GRAHAM GREENE

PANTHEON

CITY OF
SPADES

A NOVEL BY
Colin MacInnes

COCKFIGHTER

a novel by
CHARLES WILLEFORD

author of THE BURNT ORANGE HERESY

THE
FIEND

MARGARET
MILLAR

A
SUSPENSE
NOVEL
IN WHICH
JO MANY
WHO ADULT LIVES
ARE ENDANGERED
BY THE
HORRIBLE THREAT
TO A
LITTLE GIRL'S
LIFE

BY THE AUTHOR OF
VON LIKE AN ANGEL AND STRANGER IN MY GRAVE

For Love
Alone

CHRISTINA STEAD

CHARLES

A Guide
for the
Undehemorrhoided

VLADIMIR·NABOKOV

LOLITA

VOLUME I

by Wilson Tucker

the Long Loud Silence

ROCK
AND
ROLL
WILL
STAND

EDITED BY GREIL MARCUS

The Tower of
Babel

Elias Canetti

TRANSLATED BY C.V. Wedgwood

JAMES M. CAIN

GALATEA

BORZOI BOOKS

TWO
NOVELS
BY
JAMES M.
CAIN

THE
EMBEZZLER
DOUBLE
INDEMNITY

CAIN

The Institute

HERMIT IN PARIS
Autobiographical Writings

Italo Calvino

The Dispossessed

DON CARPENTER

TURNAROUND

SIMON AND
SCHUSTER

DON CARPENTER

CANETTI

The Human Province

Seabury

THE SECRET HEART OF THE CLOCK

ELIAS CANETTI

FARRAR
STRAUS
GIROUX

KRAZY KAT

JAY CANTOR

KNOPF

THE CLASS OF 49

Don Carpenter

The Murder of the Frogs

Don Carpenter

Harcourt,
Brace &
World

BLADE OF LIGHT

Don Carpenter

The Marriage of Sticks

Harcourt Brace & World

JONATHAN CARROLL

the
WOODEN
SEA

JONATHAN CARROLL

MICHAEL CHABON

WEREWOLVES IN THEIR

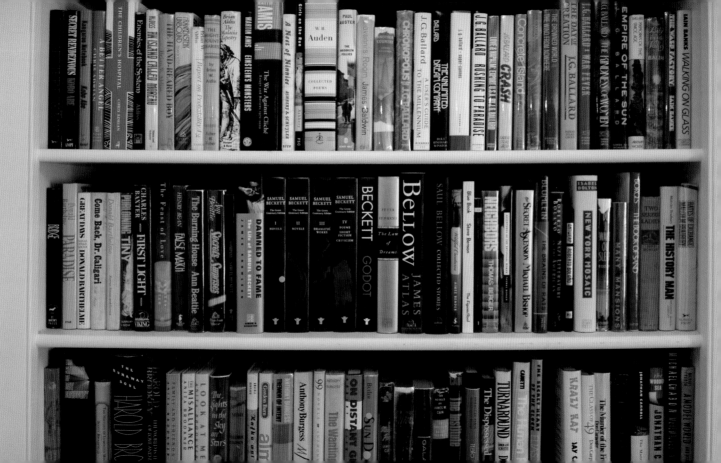

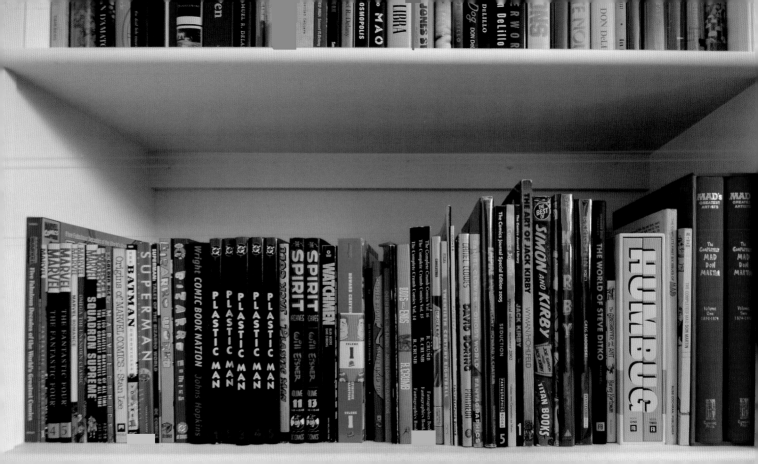

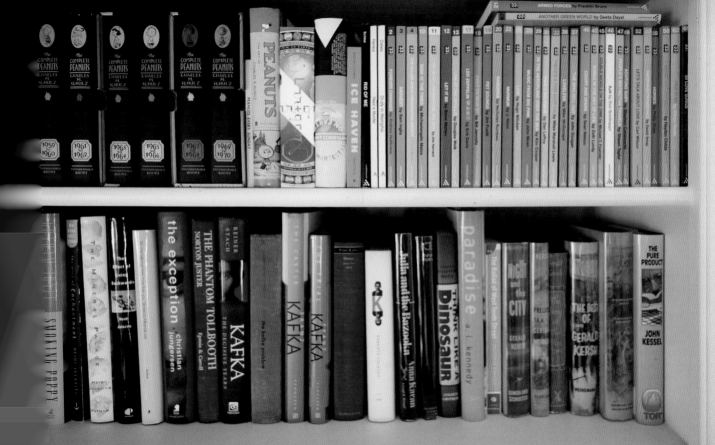

Top shelf (left to right):
- Kenneth Koch — One Train
- STRAITS — Kenneth Koch
- SUN OUT — Kenneth Koch
- A Possible World — Kenneth Koch
- On the Great — Kenneth Koch
- ON THE EDGE — Kenneth Koch
- The Complete Short Science Fiction of C. M. Kornbluth — **His Share of Glory**
- DOCTOR'S JOB
- WAITING FOR NOTHING AND OTHER WRITINGS — Tom Kromer
- ROUND UP — RING LARDNER
- Delirium Eclipse — James Lasdun
- THE HORNED MAN — James Lasdun
- ...ARRIVE AT EASTERWINE...
- out west free to see
- THE WINDS TWELVE QUARTERS — Le Guin
- STANISLAW LEM — UNLOCKING THE AIR and Other Stories — Ursula K. Le Guin
- ONE HUMAN MINUTE — LEM — TALES OF PIRX THE PILOT
- LEM EDEN
- MEMOIRS FOUND IN A BATHTUB
- LEM — THE CYBERIAD — Seabury
- LEM MICROWORLDS
- LEM A PERFECT VACUUM
- STANISLAW LEM — RETURN FROM THE STARS
- LEM — HOSPITAL OF THE TRANSFIGURATION
- Return on Earth — LEM

Bottom shelf (left to right):
- THE INVESTIGATION — LEM
- FIASCO — LEM
- LEM — HIS MASTER'S VOICE
- THE FUTUROLOGICAL CONGRESS — Stanislaw Lem
- Stanislaw Lem — THE CHAIN OF CHANCE
- STANISLAW LEM — MORE TALES OF PIRX THE PILOT — Seabury
- MORTAL ENGINES — Stanislaw Lem
- THE LIGHT OF FALLING STARS — J. Robert Lennon
- MAILMAN — J. Robert Lennon
- DORIS LESSING STORIES
- MONKEY'S WRENCH — Primo Levi
- C. S. LEWIS — An Experiment in Criticism
- stranger things...
- WHERE ALL THE LADDERS START
- MAGNETIC FIELDS — ANDRÉ BRETON
- Little Sisters
- Enchantment
- REAL PEOPLE — Alison Lurie
- The Big Merchant
- ADVERTISEMENTS FOR MYSELF — NORMAN MAILER
- OF A FIRE ON THE MOON — NORMAN MAILER
- the NAKED and the DEAD
- NORMAN MAILER — THE PRISONER OF SEX
- Answer from Limbo
- HEROVIT'S WORLD — BARRY MALZBERG
- SCREEN — Green Mars in the Dream Jennifer Barry N. Malzberg
- GALAXIES — Barry N. Malzberg
- CHORALE — Barry N. Malzberg

Claire Messud
& James Wood

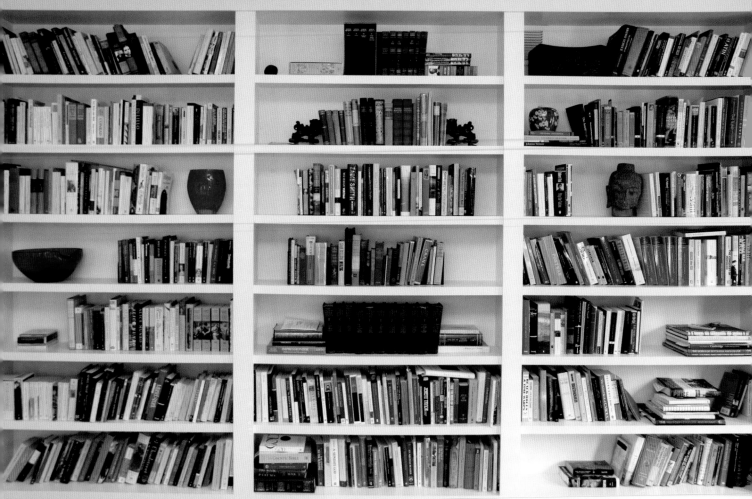

An Interview with
Claire Messud

LEAH PRICE: How far back does your collection stretch? When were the first books that you still own acquired? At what age did you start buying books? Which ones have you kept, and shed, as you moved?

CLAIRE MESSUD: Most of my earlier books are from high school or college—I've got lots of worthy tomes from university (Auerbach! Lacan! Jameson! Fish!), though I've passed on more than a few, by now, to more diligent academic readers than I. (I come from a family of book hoarders: at one point, when clearing my things rather belatedly out of my parents' house, I separated out two boxes of university books to give away, only to discover much later that my mother had simply reshelved all those books into her own library.)

But I do have on the shelves some books of poetry that I was given as a child—two books of Australian Aboriginal myths, with beautiful illustrations; and an edition of a famous Australian poem by Banjo Patterson. I've also got the books I was given as prizes for coming first in class in my third- and fourth-grade classes at my girls' school

in Sydney, in 1974 and 1975: the first is *Dolphins, Whales, and Other Sea Mammals,* and the second is *Reptiles and Amphibians*. They're both beautiful picture books, but I've barely looked at them in all these years.

At what phases of your existence has reading books—and owning books—been most important to you?

Owning books has been only intermittently of importance to me. At one time, collecting books that were my own, feeling I had my own intellectual and literary trajectory visible before me, seemed necessary and meaningful. But now, in midlife, I feel that my tendency to acquire books is rather like someone smoking two packs a day: it's a terrible vice that I wish I could shuck. I love my books, and with all their dog-ears and underlinings they are irreplaceable; but I sometimes wish they'd just vanish. To be weighed down by things—books, furniture—seems somehow terrible to me. It's important to be ready to move on. My father had a cousin who kept everything, including his

dishes, in packing cases. Each night at dinnertime, he'd take out the plates he needed and then wash them and put them back in the boxes. That way, he was always ready for the next move.

Could you say something about the books you selected for our top ten?

It's funny, the books I chose for the list are like family. I feel as though they've been part of my psyche for as long as I can remember. Or else, as in the case of Bernhard, I can remember exactly when they joined the family: I was looking for Bernanos in the stacks of the American Library in Paris in the spring of 1999, when we spent a few months living and working there. Bernhard was next to Bernanos, and the spines of his books attracted me. I took a couple to my desk, and that was that. He was family.

Are your books interfiled with James Wood's, or do you distinguish between books that entered your household via one or another of its members?

Some of our books are separate—poetry and literature, mostly—and some are combined—history, say, or travel books. Certainly we both know at once which books properly belong to one or the other of us, and by the same token, know which books are somehow shared. I can't explain how we know this, but as far as I recall, we've never disagreed about a single volume.

Do you use an e-reader (Kindle, iPad, cell phone)?

I like best to read in bed, lying down, on my side, the way I read when I was a kid: I can't imagine going to bed with a cell phone or an iPad.

What do you imagine your library looking like five, ten, twenty years from now? Do you think you'll still own objects made of paper and glue? And—with apologies for a morbid question—do you ever think about what will happen to your library after your death?

These days, I think a lot about what will happen to my library after my death, not least because my father died recently and my mother is in poor health, and we are now trying to dismantle their extraordinary collection of books. Some will find good homes—the Center for Middle Eastern Studies at Harvard has taken my father's Middle Eastern collection, which is fantastic—but others, I fear, will be harder to place. If only we can find new readers for them, wherever or however, then that's a good thing.

But that's not a reason not to have objects made of paper and glue. Doesn't anybody but me ever imagine an apocalypse after which there is no electricity, no computers? Or even the simple and constant problem of the obsolescence of technology, that makes information hard to hold onto over time? The notion that we can do without knowledge on glue and paper—and that we wouldn't want the many pleasures of objects made of glue and paper—is, to me, absurd. Anybody who thinks books are dispensable is someone entirely lacking in appreciation of sensual pleasure. I pity such a person.

Top Ten Books
Claire Messud

Leo Tolstoy
Anna Karenina

Elizabeth Bishop
*The Complete
Poems, 1927–1979*

Arthur
Schopenhauer
*Essays and
Aphorisms*

Thomas Bernhard
Gathering Evidence

Fyodor
Dostoyevsky
*Notes from
Underground*

Henry James
*The Portrait of
a Lady*

Gustave Flaubert
*The Letters,
1830–1857*

Alice Munro
Selected Stories

Marcel Proust
Swann's Way

Italo Svevo
Zeno's Conscience

WORDSWORTH CLASSICS

LEO TOLSTOY

*Anna
Karenina*

Elizabeth Bishop

The Complete Poems

1 9 2 7 – 1 9 7 9

PENGUIN CLASSICS

ARTHUR SCHOPENHAUER

Essays and Aphorisms

THOMAS
BERNHARD

GATHERING
EVIDENCE

A MEMOIR

PENGUIN
BOOKS

NOTES FROM
UNDERGROUND

FYODOR DOSTOYEVSKY

PENGUIN CLASSICS

HENRY JAMES

The Portrait of a Lady

The Letters of
GUSTAVE
FLAUBERT
1830–1857

SELECTED, EDITED, AND TRANSLATED
BY
Francis Steegmuller

Alice
Munro

SELECTED
STORIES

With a new
introduction by
the author

Swann's Way

Marcel Proust

ZENO'S CONSCIEN

ITALO SVEVO

LEAH PRICE: How far back does your collection stretch?

JAMES WOOD: I have books from my teenage years, complete with clumsy and naïve annotations. But the naïveté tells a story, which is a love affair: the margins of the old books are filled with exclamations like "wonderful!" and "fantastic!" (or the odd admonitory "this doesn't work"), as I worked out what I liked and why, over the years, and what I didn't like and why. I started buying books as a child—the whole English culture of "book tokens" and school prizes (whose money you could only spend on a book) was helpful in that regard. Then I had a period of lifting books from shops, because I didn't have the money but *had* to have the books. Informal research has shown that I was not alone in this vice. I gave it up in my late teens, less out of remorse—I am ashamed to say—than out of fear of being caught (and perhaps due to increasing prosperity).

Could you say something about the books you selected for our top ten? Which are the ones you would grab first if a fire broke out?

For my top ten books I confined myself to fiction written (or published, in the case of the Chekhov translations) in the twentieth century; not because these are necessarily the best, but because (as Virginia Woolf once wrote) one feels differently, more tenderly, more possessively, towards and about contemporary literature—it belongs to us in a way that Cervantes doesn't. I suppose that what is notable about the list—notable not about my taste but about fiction in general—is that it is marked by a tendency towards the comic, or towards the tragic-comic: this is obviously true of Chekhov, Henry Green, Naipaul, Bellow, the wonderful Czech novelist Bohumil Hrabal, and of Joseph Roth. Woolf's *To the Lighthouse* (which could do with a bit more comedy, actually!) is one I reread every year, with ever greater admiration and love.

In my library, the books that mean most to me are the ones that made a decisive impact on my development, the ones I can remember reading in a certain time and place, with joy and discovery. The affection one has for these books has, in my case, nothing to do with the quality of the books as objects. Often, they are the cheapest, and most beaten-up paperbacks: the old Penguin editions of Nietzsche, for instance; Benjamin's *One-Way Street;* the ugly old Penguin editions (with hideous cover art) of Bellow's novels; that absurdly expensive, half-read book of literary theory from MIT Press, whose first pages made such an impression . . . I like the idea of a library being not materially imperishable, but on the contrary, materially replaceable. I tend to write all over my books, drop them in the bath, stuff them into pockets, and so on. So if there were a fire, I wouldn't bother taking any of the paperbacks, happy in the knowledge that I could get them all again, in newer and probably better editions.

The bookshelf, literally: what are your shelves made of? How did you acquire them?

They are newish—made last year by a carpenter, and the first custom-made, fitted shelves we have ever owned. Most of my books are not in these

shelves but upstairs, on the cheapest trestle shelves (the ones made of three shelves per unit, whose gates swing out, and which generally sell for about fifty dollars each). These new, fitted shelves, which I like very much, and which make me feel quite grown-up, are the "show-shelves."

What books are *not* on the shelves you allowed us to photograph?

I have a separate bookcase for "unread books I want to read sometime soon." Of course, it's enormous and dispiriting.

Do you lend your books to friends?

There is a simple rule: practice a kind of generous selfishness. Give a book to a friend, but don't lend it, because you will *never* get it back.

Do you mark up your books?

I deface nearly all my books, with both annotations in ink, and lots of dog-earing. I also regularly write to-do lists in the endpapers, or telephone numbers, or names of people I must e-mail. These latter often prove more interesting than any of my literary comments: years later, I stare at them, trying to work out who these people were.

What do you imagine your library looking like five, ten, twenty years from now? Do you think you'll still own objects made of paper and glue? And (with apologies for a morbid question) do you ever think about what will happen to your library after your death?

I think my library will look much the same in twenty years. I would happily get rid of my books before I die, so that my children don't have to throw them out themselves (which they assuredly will do). A few years before his death, Frank Kermode was moving house and had some boxes of his most precious books out on the street, ready for the movers. Alas, the garbage men came by and mistakenly took them away, and compacted

them. In a stroke, he lost all his first editions and most prized dedication copies; he was left with only his cheapest paperbacks, and his collection of literary theory. There's a parable lurking there.

Top Ten Books
James Wood

Anton Chekhov
Stories

W. G. Sebald
Austerlitz

Virginia Woolf
To the Lighthouse

Willa Cather
*Death Comes for
the Archbishop*

Bohumil Hrabal
Too Loud a Solitude

V. S. Naipaul
*A House for
Mr. Biswas*

Henry Green
Loving

Cesare Pavese
*The Moon and
the Bonfire*

Joseph Roth
*The Radetzky
March*

Saul Bellow
Seize the Day

W. G. Sebald

AUSTERLITZ

BLACKROD CLASSICS

WILLA
CATHER

Death Comes For
The Archbishop

V. S. NAIPAUL
WINNER OF THE NOBEL PRIZE IN LITERATURE

A House for Mr Biswas

The celebrated British author—
His most famous novel...
Henry Green

Loving

"A work of art"
—The New Yorker
"One of the
living novelists
I admire the most"
—Elizabeth Bowen

The Moon
and the Bonfire
Cesare Pavese

The
Radetzky
March
JOSEPH ROTH
A NEW TRANSLATION BY JOACHIM NEUGROSCHEL
WITH AN INTRODUCTION BY NADINE GORDIMER

PENGUIN CLASSICS

SAUL BELLOW
Seize the Day
Introduction by CYNTHIA OZICK

ANTON CHEKHOV

STORIES

TRANSLATED BY
RICHARD PEVEAR AND LARISSA VOLOKHONSKY
WITH AN INTRODUCTION BY RICHARD PEVEAR

VIRGINIA
WOOLF

TO THE
LIGHTHOUSE

'devastating . . . a superb book and a magnificent author'
INDEPENDENT

Too Loud a Solitude
BOHUMIL HRABAL

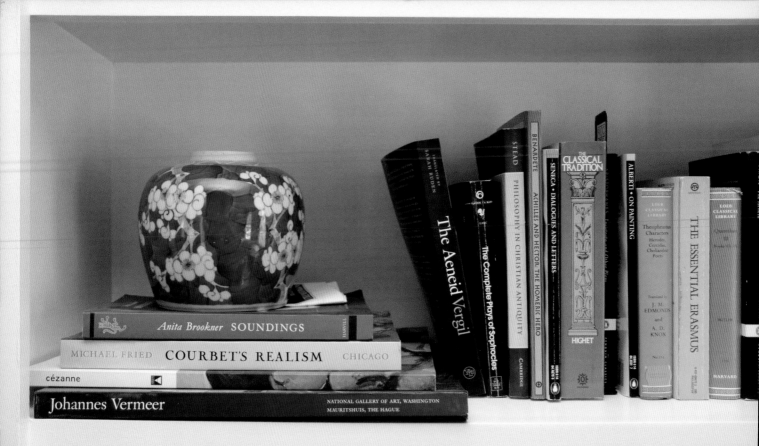

Anita Brookner SOUNDINGS

MICHAEL FRIED COURBET'S REALISM CHICAGO

cézanne

Johannes Vermeer

NATIONAL GALLERY OF ART, WASHINGTON
MAURITSHUIS, THE HAGUE

The Aeneid Vergil

STEAD

The Complete Plays of Sophocles

PHILOSOPHY IN CHRISTIAN ANTIQUITY

CAMBRIDGE

BENARDETE

ACHILLES AND HECTOR: THE HOMERIC HERO

SENECA · DIALOGUES AND LETTERS

THE CLASSICAL TRADITION

HIGHET

ALBERTI · ON PAINTING

LOEB CLASSICAL LIBRARY

Theophrastus Characters

Herodes, Cercidas, Choliambic Poets

Translated by J. M. EDMONDS and A. D. KNOX

THE ESSENTIAL ERASMUS

LOEB CLASSICAL LIBRARY

HARVARD

THE EPICUREAN PHILOSOPHERS EDITED BY JOHN GASKIN

Bernanos La liberté, pour quoi faire?

THE REBEL CAMUS QQ 274 SEUIL

Albert Camus The Myth of Sisyphus VINTAGE

E.M.Cioran THE TEMPTATION TO EXIST

E.M.Cioran ANATHEMAS AND ADMIRATIONS

COLERIDGE A DISCOURSE ON METHOD MEDITATIONS AND PRINCIPLES

Diderot, d'Alembert, and others Confessions of an Inquiring Spirit RENÉ DESCARTES

DIDEROT · SELECTED WRITINGS Encyclopedia 223 Stanton SP 43 BOBBS MERRILL

ECKHART · SELECTED WRITINGS ON ART AND LITERATURE

The Epicurus Reader ISBN 0 87 220 0 241

THE EPICUREAN TRADITION HOWARD JONES

GOD IN US ANTHONY FREEMAN HACKETT 0241

FREUD The Psychology of Love

FREUD 14 ART AND LITERATURE ROUTLEDGE

SIGMUND FREUD PENGUIN CLASSICS

VOLUME 13 FREUD Jokes and Their Relation to the Unconscious PENGUIN CLASSICS

FREUD The Origins of Religion Sigmund Freud ISBN 0 14 02 147 9

CLASSICS OF FREE THOUGHT Sigmund Freud The Uncanny NORTON

W.K.C.GUTHRIE THE GREEK PHILOSOPHY ISBN 0 14 01 3602 4 PENGUIN

Essays in Aesthetics ERNEST GELLNER THE PSYCHOANALYTIC MOVEMENT Edited by Paul Blanshard Goldsworth

Philip Pullman

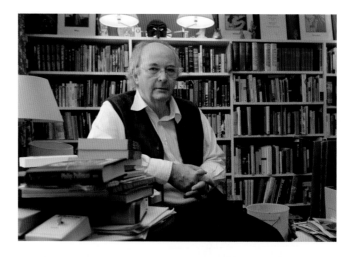

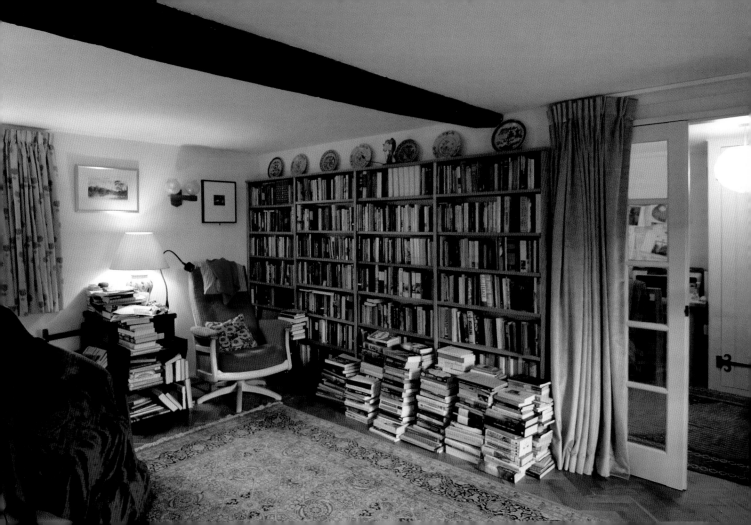

My collection stretches back to my childhood. I can date it more or less precisely: I still have the book I took out of our family bookshelf when, at the age of eight, we set off to sail from London to Australia (and of course I don't mean sail, I mean go by sea, that being the usual mode of long-distance transport in the 1950s). The book was a selection of the poems of Longfellow, including a lot of *Hiawatha,* which I read with avidity. I don't know why I chose that book: I suppose I wanted to impress people.

I started buying books . . . well, as soon as I had enough money. Relatives used to give me book tokens as birthday presents, and if I won a prize at school it would usually be a book. I remember borrowing Lawrence Durrell's *Balthazar* from the mobile library when I was . . . what would I have been? About fifteen, I suppose. I was so taken with its mixture of what seemed very grown-up sophistication and sensuality that I promptly bought *Mountolive* and *Clea* from the local W. H. Smith's, that being the closest thing to a bookshop in the part of north Wales where we lived. My uncle contributed *Justine,* which he'd bought and not liked

very much, and I still have that set of the once highly celebrated *Alexandria Quartet*. Reading it now, it's not hard to see why it went out of literary fashion; but it's not hard, either, to see why it was perfect reading for the sort of teenager I once was. I don't believe in dissing books I used to love, and I always suspect the moral judgment of people who sneer at the taste of the reader they used to be: "I know thee not, old book."

There's never been a phase in my life when books were not important, and nor has there been a time when I stopped reading. It's almost as important as breathing.

The top ten was rather hastily assembled. I stand by it, but of course if I'd had longer to think about it I would have chosen slightly differently, no doubt. There are four books that would remain, I think. One is the famous Donald Allen anthology *The New American Poetry, 1945–1960*. I have a modern edition, but the one I saw first (when I was sixteen) exploded all my ideas of what poetry was and could be. I did have ideas about that, because another of my top ten, Palgrave's *Golden Treasury*,

accompanied me everywhere for two or three teenage years. It was the most popular British anthology of verse, the embodiment of traditional taste, which meant that all the famous poems were there. I loved them, and I still do. But *The New American Poetry, 1945–1960* knocked that all into exhilarating, intoxicating, inspiring, enthralling confusion and showed me new colors and new sounds and new forms of delight. Ginsberg's *Howl:* how could I forget my first encounter with that? And it was Ginsberg who led me to William Blake, hence my battered little paperback *Selected:* another inexhaustible and much-loved companion, and perhaps the one I would grab if a fire, et cetera.

My shelves are made of wood. We moved to this house eight years ago, because we thought that at last we'd have room for all our books. No chance! Of making many books there is no end, as the Bible remarks somewhere. I had a lot of bookshelves made to cover every suitable wall, and before a year was up they were all filled, and piles of books were covering the floor. Every time I go into town I accidentally buy two or three books. Publishers

bombard me with books they want a puff for. Foreign editions of my own books crowd in from all over the world like eels making for the river where they were spawned.

Arrangement: when we first moved here I paid my younger son to arrange the books in my downstairs "study." He has a librarian's mind, and his arrangement held good until so many more books arrived that they just swamped the categories and burst the banks of the subject headings. Now it's just memory and guesswork that guide me to this pile or that shelf or that corner of the floor. I'm often delightfully surprised by a book I'd totally forgotten.

When I'm working on something, I keep the most useful and relevant books near me on the table where I work. The most important book of all (the fourth unremovable from my top ten) is my much-repaired 1959 edition of Chambers. It's the right size for one hand to pick up. Dictionaries have got bigger and bigger, unnecessarily, it seems to me. I like Chambers because of its pawky wit. Sometimes a definition will unexpectedly snap at you, as for example *double-locked: locked by two turns of the key, as in very few locks but many novels.*

Books unphotographed: there are cookery books in the kitchen—about three times as many as I use. I could cull those with no difficulty. Perhaps I shall. Phone books? Next to the phone. Pornography? No. On the bedside table I keep whatever thriller I'm currently reading in bed (at the moment, John Le Carré's *The Honourable Schoolboy*). I've been reading a lot of Lee Child recently. I like thrillers, and I read them unironically. James Lee Burke is astonishingly good.

How does the reading feed into the writing, and vice versa? Continually, continuously, promiscuously, in a million ways. Perhaps I'll write about it in greater detail one day: a memoir in terms of books. It's been done, before, of course, like everything else.

The Kindle: maybe we're on the cusp of a revolution as great as Gutenberg's, but then maybe we're not. No invention was ever as great as the codex; it's still unsurpassed. Reading the Kindle is sort of like reading a book, because there's nothing

else you can do on it: you can't check your e-mails or look for the football results. No built-in distractions. And it's also sort of like reading a book because the text is arranged in sort of pages. It's much less easy to navigate through, though, and they just haven't got the hang of poetry yet: the formatting is all over the place. But the ability to take hundreds of books with you in one little slab of plastic! For traveling, for weekends away, and so forth! What a boon!

On the other hand, I mistrust any device whose continued usage depends on a vast, mysterious, and invisible infrastructure of electricity supply, computer servers, broadband connections, credit facilities, and so on. A printing press can exist and work in a room anywhere, with no electricity at all, and the paper and the ink and the bookbinding have a kind of artisanal comprehensibility, but the computer . . . When the big crash comes, I shall throw away my Kindle without a moment's regret; but my books will last as long as I do. Have I got enough now to last the rest of my life? Could I get by without ever acquiring another? Oh, I think

so. But I'm so looking forward to X's biography of Y, and I must get that book of medieval Hebrew poetry I read about in the NYRB, and A was enthusing to me about B's forthcoming novel, and I liked her last so much . . . So I'll continue to fill the house with books, and never mind the consequences.

Occasionally I get rid of some. I'll buy thrillers even if I know nothing about them, and sometimes I do and the writing is so bad I can't bear to read more than a page; or there are the several dozen books in the *Library of East Anglia* series that a grateful publisher sent me because I wrote a few obliging paragraphs about his latest rediscovery; and it would be nice to keep one copy of the Thai edition of my fairy tales, but do I really need *ten?* So from time to time I go through and pick out everything I don't want and take it to the charity shop. It's only skimming the froth, though; I'm sure there are many lurking in the depths that I know I don't want. But I never see them.

Top Ten Books
Philip Pullman

Ruthven Todd, ed.
Blake

Fernando Pessoa
The Book
of Disquiet

Hergé
The Castafiore
Emerald

Chambers's
Twentieth Century
Dictionary

Elizabeth Bishop
The Complete
Poems, 1927–1979

Italo Calvino
Italian Folktales

George Eliot
Middlemarch

Donald Allen, ed.
The New American
Poetry, 1945–1960

Arthur Quiller-
Couch, ed.
The Oxford Book
of Ballads

Francis Turner
Palgrave, ed.
The Golden Treasury
of the Best Songs
and Lyrical Poems
in the English
Language

The Book of Disquiet

CHAMBERS'S TWENTIETH CENTURY DICTIONARY

Elizabeth Bishop
The Complete Poems
1927–1979

DELL
THE LAUREL POETRY SERIES
BLAKE

ITALIAN FOLKTALES
SELECTED AND RETOLD BY
ITALO CALVINO

*'Calvino possesses the power of seeing
into the deepest treasures of human minds
and bringing their dreams to life'*
— Salman Rushdie in the London Review of Books.

MORE THAN
100,000
COPIES SOLD

THE NEW
AMERICAN
POETRY
1945–1960

The visionary
anthology
that influenced
two generations
of poets and readers

EDITED BY
DONALD ALLEN
With a new afterword

Helen Adam • Brother Antoninus
• John Ashbery • Paul Blackburn
• Robin Blaser • Ebbe Borregaard
• Bruce Boyd • Ray Bremser
• James Broughton • Paul
Carroll • Gregory Corso • Robert
Creeley • Edward Dorn • Kirby
Doyle • Richard Duerden • Robert
Duncan • Larry Eigner • Lawrence
Ferlinghetti • Edward Field
• Allen Ginsberg • Madeline
Gleason • Barbara Guest
• LeRoi Jones • Jack Kerouac
• Kenneth Koch • Philip Lamantia
• Denise Levertov • Ron
Loewinsohn • Edward Marshall
• Michael McClure • David
Meltzer • Frank O'Hara • Charles
Olson • Joel Oppenheimer
• Peter Orlovsky • Stuart Z.
Perkoff • James Schuyler • Gary
Snyder • Gilbert Sorrentino
• Jack Spicer • Lew Welch
• Philip Whalen • John Wieners
• Jonathan Williams

THE OXFORD BOOK
OF
BALLADS

THE
GOLDEN TREASURY
OF THE BEST SONGS AND LYRICAL
POEMS IN THE ENGLISH LANGUAGE
Selected and arranged by
FRANCIS TURNER PALGRAVE

With Additional Poems

OXFORD UNIVERSITY PRESS
LONDON : HUMPHREY MILFORD

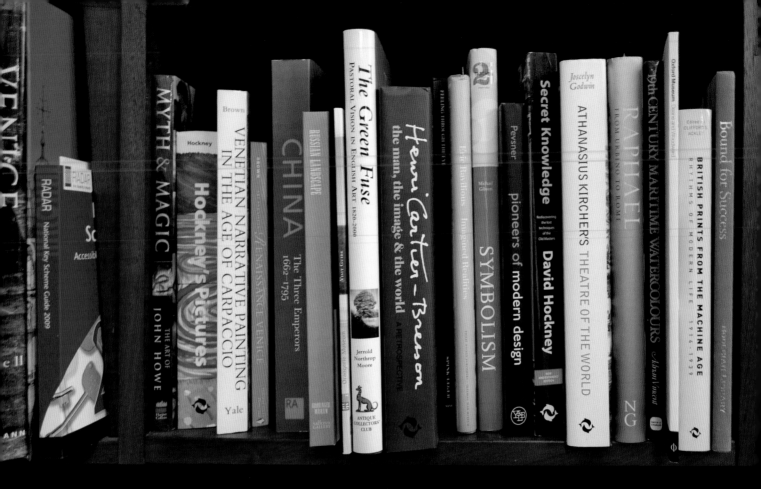

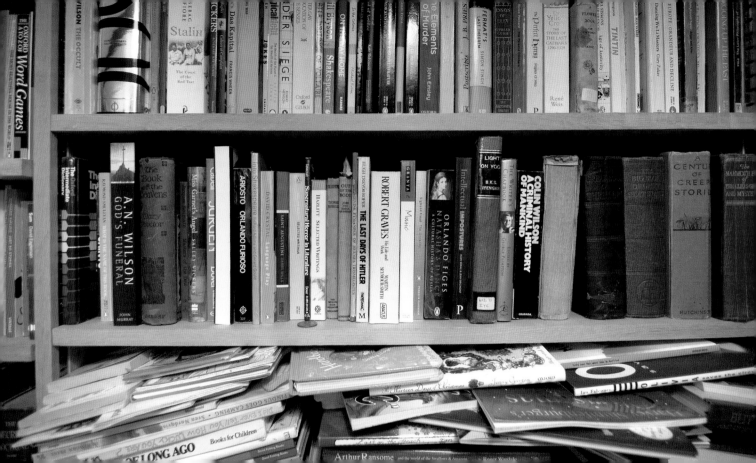

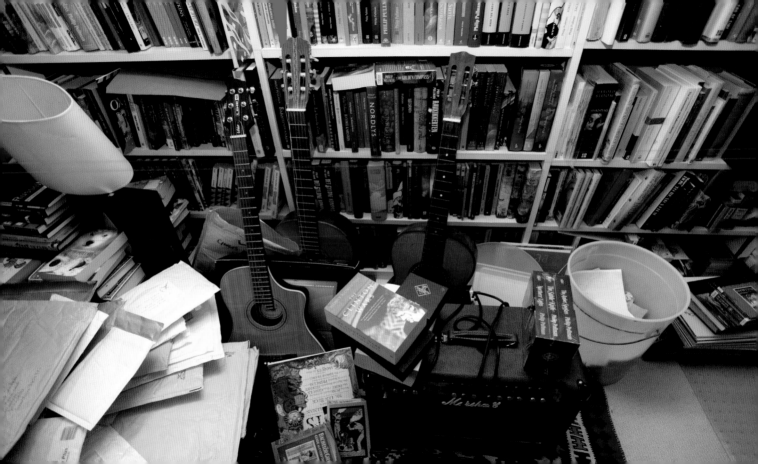

R HISTORY OF TIME — STEPHEN HAWKING with Leonard Mlodinow — BANTAM PRESS

OSTICISM — Benjamin Walker

AN DARK ANGELS JOHN SIMMONS

THE LAST ENEMY — RICHARD HILLARY — PIMLICO

BOGHOSSIAN — fear of knowledge — OXFORD

Is there a book in you? — Alison Baverstock — A & C B

10THY RADCLIFFE OP — WHAT IS THE POINT OF BEING A CHRISTIAN? — burns & oates

Reformation — EUROPE'S HOUSE DIVIDED 1490–1700 — DIARMAID MacCULLOCH

Journals of Gilbert White — Johnson, editor

PASTERNAK, TSVETAEVA, RILKE — nyrb

David Crystal — Who Cares About English Usage?

Raymond Smullyan — FOREVER UNDECIDED — A PUZZLE GUIDE TO GÖDEL — ISBN 0 14 02.25447 — OXFORD

all THE ALTERNATIVE TRINITY — OXFORD

Concentration — GEORG ALLEN AND UNWIN

ON THE KABBALAH AND ITS SYMBOLISM — SCHOLEM — SCHOCKEN

Witold Rybczynski — THE MOST BEAUTIFUL HOUSE IN THE WORLD — ISBN 0 14 01.5566 2

THE OXFORD A TO Z OF Word Games — COLIN TUDGE — PIMLICO — OXFORD

THE DAY BEFORE YESTERDAY

THE PALLISER NOVELS

Can You Forgive Her?

ANTHONY TROLLOPE

468

THE WORLD'S CLASSICS

309

CAN YOU FORGIVE HER?

Anthony Trollope

OXFORD

THE LAST CHRONICLE OF BARSET

Anthony Trollope

398

THE WORLD'S CLASSICS

OXFORD

DOCTOR THORNE

ANTHONY TROLLOPE

WORLD'S CLASSICS 298

M

OXFORD

FRAMLEY PARSONAGE

Anthony Trollope

305

THE WORLD'S CLASSICS

OXFORD

HE KNEW HE WAS RIGHT

Anthony Trollope

507

THE WORLD'S CLASSICS

OXFORD

TURGENEV — VIRGIN SOIL

Translated by ROCHELLE S. TOWNSEND

Introduction by DR NICOLAY ANDREYEV

£L

No. 528 in EVERYMAN'S LIBRARY

DENT

DUTTON

FIRST LOVE

Ivan Turgenev

1924

THE HUNTING SKETCHES

Ivan Turgenev

Turgenev FATHERS AND SONS

L 147

THE TORRENTS OF SPRING

Turgenev

1933

COLIN M TURNBULL

THE FOREST PEOPLE

World BOOKS

Amos Tutuola

TWAIN — THE ADVENTURES OF HUCKLEBERRY FINN

FABER

John Updike Rabbit, Run

U.S. $95

John Updike Rabbit is Rich

THE PULITZER PRIZE WINNER

Pulitzer Prize Winner

U.S. $95

8-449 24548-8

John Updike Rabbit at Rest

CAN $95

8-449 21962-3

SALLEY VICKERS MISS GARNET'S ANGEL

Slaughterhouse 5

Kurt Vonnegut

Panther

THE GADFLY

E. L. VOYNICH

WU CHENG-EN MONKEY

THE PROFESSOR

WARD

THE MAN WHO BOUGHT LONDON

EDGAR WALLACE

THE HOLOCAUST

WARNER · Phantasmagoria

SPECULATIONS · Hulme · ROUTLEDGE

Michel Montignac · EAT YOURSELF SLIM · M

THREE FILMS OF W. C. FIELDS

BETTER GARDENING · Robin Lane Fox

Ruskin · THE SEVEN LAMPS OF ARCHITECTURE · Dover 0-486-26145-X

thirty secret years · A.G. Denniston's work in signals intelligence 1914–1944 · Robin Denniston

MICHAEL BERKELEY · Private Passions

Festival of Britain DESIGN 1951

CINEMA PARADISO

JOHN RUSKIN · PRAETERITA

JAMES OUTRAM · A BIOGRAPHY · VOL. I · SIR F. J. GOLDSM

JAMES OUTRAM · A BIOGRAPHY · VOL. II · SIR F. J. GOLDSM · SMITH, ELDER & CO

RUSKIN'S VENICE · THE STONES REVISITED · Sarah Quill · Ashgate

JOHN COWPER POWYS

THE
BRAZEN
HEAD

JOHN
COWPER
POWYS

GREGOIRE GARDETTE John Cowper Powys

EBONY AND IVORY

MR WESTON'S GOOD WINE

226

MARCEL
PROUST

In Search of
Lost Time

I

Swann's Way

MARCEL
PROUST

In Search of
Lost Time

II

Within a Budding
Grove

MARCEL
PROUST

In Search of
Lost Time

III

The
Guermantes
Way

MARCEL
PROUST

In Search of
Lost Time

IV

Sodom
and Gomorrah

MARCEL
PROUST

In Search of
Lost Time

V

The Captive
The Fugitive

MARCEL
PROUST

In Search of
Lost Time

VI

Time Regained
A Guide to Proust

Philip Pullman

Swann's Way MARCEL PROUST

GOLLANCZ

The Amber Spyglass

PHILIP PULLMAN

SCHOLASTIC PRESS

Northern Lights

PHILIP PULLMAN

SCHOLASTIC PRESS

The Adventures of Natalie Ginzburg

Gary
Shteyngart

LEAH PRICE: When I asked other authors whether they read e-books, they often justified a negative answer by invoking nonvisual senses: in particular, smell, the pleasure they take in the whiff of paper and glue. Your latest novel turns this logic on its head, picturing a future (or present) in which people glued to machines that bear a suspicious resemblance to iPhones hold their noses when confronted with a book, let alone a bookshelf. One character compares the smell of books to the smell of wet socks. So: how do the senses play into your experience of reading? Does the physicality of books matter to you, for good or for bad?

GARY SHTEYNGART: Yes, I'm big on sniffing books. The old Soviet ones really have this strong smell, reminding me, for some reason, of tomato soup in a cheap Soviet cafeteria.

How far back does your book collection stretch?

The oldest book in my collection is one of the first books I read as a four- or five-year-old. A Swedish children's book, in Russian, the title of which

translates as *The Adventures of Nils and the Wild Geese*. The book rapidly began to fall apart from many readings and is lovingly wrapped up in layers upon layers of Soviet masking tape.

Could you say something about the books you selected for our top ten?

Nabokov's *Pnin* is very important. A work that is so humane and at the same time hilarious. But let's not forget my full collection of *Sopranos* DVDs. This is storytelling for the new century.

The bookshelf, literally: what are your shelves made of? How did you acquire them?

Oh, they're just from Design Within Reach. The Index Four and Index Three bookshelves. Taken together and filled with colorful books, I think they add a sense of drama to the living room.

How do you arrange, or attempt to arrange, your books?

Actually they're just all over the place! Some books are so good they're slightly lumped together, the Nabokovs and Roths, for example, but mostly I want to be surprised every time I look at the shelves. Who knows where anything is?

What books are *not* on the shelves you allowed us to photograph? Are there kinds of books you keep in places other than the bookshelf—cookbooks, phone books?

Travel books are relegated to a second bedroom. Cookbooks? I don't know how to cook. Phone books no longer exist, I believe.

Unlike most people's, your bookshelves contain only . . . books. (And a boxed set of *Sopranos* DVDs.) Do you object to interfiling books with knickknacks, tchotchkes, photographs?

Death to tchotchkes!

Do you listen to audiobooks? Do you prefer reading aloud or being read aloud to?

I'm so old-fashioned that I still like to read bound, printed media artifacts like books. You read, then you write, then you read some more, then more writing, and so on in an endless wordy loop.

Do you read books or magazines on your famous iPhone?

I read the *New York Times* online sometimes, and Russian papers, too. I get the *New Yorker* delivered in the mail.

Do you have any taboo against throwing away books when you're done reading them, or replacing books when they fall apart from wear and tear?

Some books are just crap and have to be thrown out. But some crappy books remind you of certain times in your life and have to be kept. In the closet.

Top Ten Books
Gary Shteyngart

The Sopranos
(season 1)

Mordecai Richler
Barney's Version

Mary Gaitskill
Veronica

Anton Chekhov
Collected Works

Sergei Dovlatov
We Met, Talked

Salman Rushdie
Midnight's Children

Chang-rae Lee
Native Speaker

Vladimir Nabokov
Pnin

Philip Roth
Portnoy's Complaint

Adrian Nicole
LeBlanc
Random Family:
Love, Drugs,
Trouble, and
Coming of
Age in the Bronx

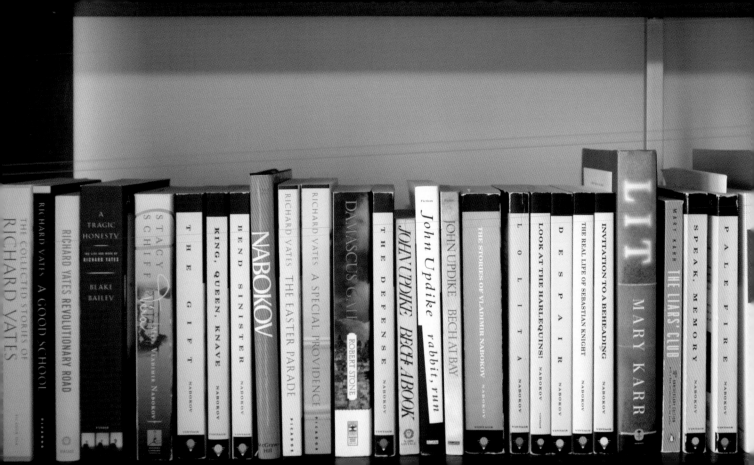

Wild Meat and the Bully Burgers — Lois-Ann Yamanaka — FARRAR STRAUS GIROUX

THE MYSTERY GUEST — GRÉGOIRE BOUILLIER — FSG

Tropic of Cancer — HENRY MILLER — Grove Weidenfeld

TWILIGHT OF THE SUPERHEROES — DEBORAH EISENBERG — FSG

THE LIFE OF INSECTS — VICTOR PELEVIN

Jeanette Winterson — THE PASSION — Grove Press

BUDAPEST — CHICO BUARQUE

THE PAT HOBBY STORIES — Fitzgerald — SL 21 — SCRIBNERS

LOW LIFE — LUC SANTE — VINTAGE

W. G. Sebald — The Emigrants — NDP853

WEEP NOT, CHILD — Ngũgĩ

Propaganda — MONUMENTAL — VLADIMIR VOINOVICH — KNOPF

Joseph Brodsky — Collected Poems in English — FSG

ANATOLE BROYARD — Kafka Was the Rage — VINTAGE

ANDORRA — PETER CAMERON — SG

Satyajit Solataya — THE SLYNX — Houghton Mifflin

Mark Doty — HARPER

Tim Parks — Destiny — Arcade

CALVIN TOMKINS — Living Well Is THE BEST REVENGE

Lerner & West — JEWS & BLACKS — Grosset/Putnam

Rules of the Wild — PANTHE

THE RACHEL PAPERS · AMIS · VINTAGE

SUCCESS · AMIS · VINTAGE

EXPERIENCE · Amis

KINGSLEY AMIS *Lucky Jim*

KINGSLEY AMIS *Every Day Drinking* · HUTCHINSON

MARTIN AMIS · MONEY · PENGUIN

MORDECAI RICHLER · WSP contemporary classics fiction

THE APPRENTICESHIP OF DUDDY KRAVITZ

THE MAN WHO WAS LATE · LOUIS BEGLEY · Knopf

LOUIS BEGLEY · *About Schmidt*

Wartime Lies · LOUIS BEGLEY · V&C

THE TREMENDOUS WORLD I HAVE INSIDE MY HEAD · LOUIS BEGLEY

A CLOCKWORK ORANGE · BURGESS

St. Urbain's Horseman/Mordecai Richler

MICHAEL CHABON · WEREWOLVES IN THEIR YOUTH · RANDOM HOUSE

MICHAEL CHABON · *The Final Solution* · 4th

Milan Kundera · IMMORTALITY

MILAN KUNDERA · *The Unbearable Lightness of Being*

THE WOMAN IN THE DUNES · ABE · VINTAGE

Milan Kundera · Life Is Elsewhere · PENGUIN

V · Thomas Pynchon · PICADOR

Akhil Sharma — AN OBEDIENT FATHER

BAKING FOR CHILDREN

MISSION TO AMERICA — WALTER KIRN

on almay perfect moment

Jhumpa Lahiri — THE NAMESAKE — binnie kirshenbaum — a novel

AT THE BOTTOM OF THE RIVER — JAMAICA KINCAID — HOUGHTON MIFFLIN

A Small Place — JAMAICA KINCAID

SIGRID NUNEZ — SALVATION CITY — FSG

Sigrid Nunez — FSG

PUB DATE SEPT 2010

Charles Dickens · A Christmas Carol — A BANTAM CLASSIC — BANTAM CHRISTMAS BOOKS — 2.95 U.S. / 3.99 CAN

Moby-Dick · Herman Melville — SIGNET CLASSIC

HEMINGWAY · THE NICK ADAMS STORIES · SCRIBNERS

In Our Time — HEMINGWAY — SCRIBNERS

EVEN THE DOGS — JON McGREGOR

THE COMPLETE PROSE OF Woolf — WINGS BOOKS

Norbert Lynton — THE STORY OF MODERN ART

THE OXFORD RUSSIAN-ENGLISH DICTIONARY — OXFORD

THE OXFORD ENGLISH-RUSSIAN DICTIONARY — OXFORD

CHILDREN of the ARBAT — ANATOLI RYBAKOV — LITTLE, BROWN

STEINBECK — THE GRAPES OF WRATH

Edmund White

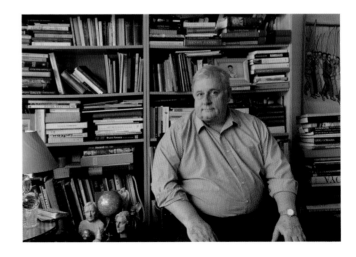

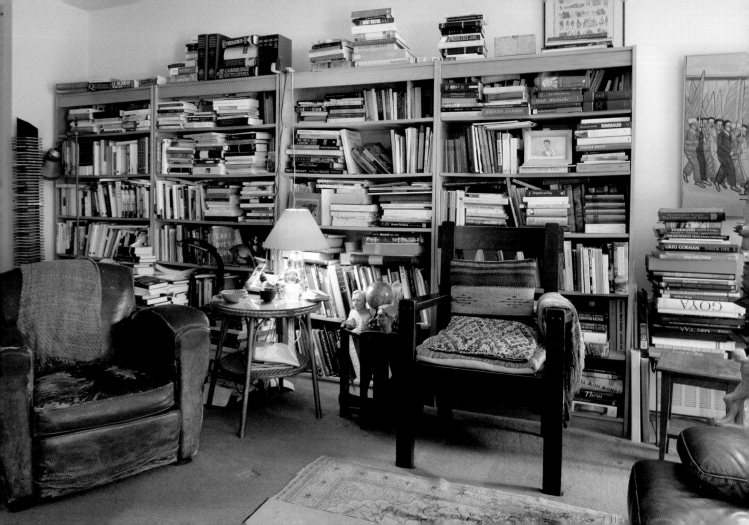

LEAH PRICE: You've said, "As a young teenager I looked desperately for things to read that might excuse me or assure me I wasn't the only one, that might confirm an identity I was unhappily piecing together." What role did books play for you before and after that?

EDMUND WHITE: I stopped reading right after college—I had had it! But then soon enough, maybe two years later, I was reading again, this time strictly for pleasure. In those days we were so poor we only bought paperbacks, though once in a while we'd borrow hardcovers from the library. I never cared about first editions or even the material condition or look of a book, and I don't think I kept books very long. I don't have any books that I acquired in my twenties, though several times I've bought some titles (Kafka, Shakespeare, Beckett, Gide) that I owned in my twenties. When twelve years ago I moved back from France, after living there for sixteen years, I had a party where the numerous guests were invited to take any and all of the books—that way I got rid of most of them.

The bookshelf, literally: what are your shelves made of?

They're wood—I think I bought them at a cheap readymade furniture store.

How do you arrange, or attempt to arrange, your books?

I don't have that many books and they're not arranged in any particular order. I think for a while I had the Genet and Proust books together, and they attracted other unrelated titles in French. My own books, which I keep in order to give away to friends, are in one section more or less. Big art books, which lie on their sides, are in yet another section. When I gave away a thousand books recently to Housing Works, I eliminated the books I thought I'd never read again or that I'd received from press services but had been too lazy to get rid of.

What books do you keep next to your bed?

Michael, my partner, has a very intimidating batch of books in his bathroom, but in mine there are just circulating books or magazines. The books beside the bed, *les livres de chevet,* are supposed to be important to the person who sleeps there, but mine aren't.

As a critic and novelist, do you find yourself reading (or annotating) different genres differently?

I would annotate any book except a costly first edition or an illustrated book that is rare. I read so much for essays I'm writing (on Ford Madox Ford, say, or Henry James or Glenway Wescott—dozens and dozens of essays, usually for the *New York Review* and usually about writers). And for these essays I consult dozens of books and annotate them; if they're from the Princeton library, I mark them with sticky notes, which I strip away and then return. Sometimes I'll go to the Strand and buy every book about Henry James's letters, for instance, that I can find, but I ship them out as soon as I'm finished with the essay.

You could say I'm pretty hostile to books as objects and space-grabbers and dust-collectors.

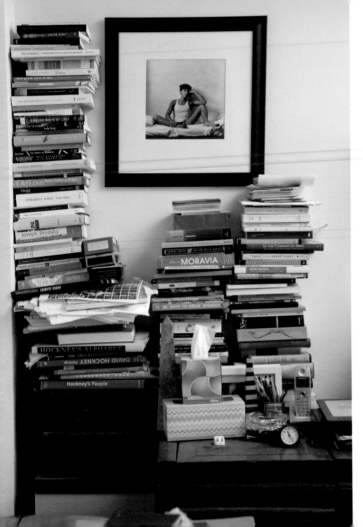

When I was younger I loved having books sitting around in cartons—paperbacks with coffee stains on the covers—and I'd read a chapter here and a chapter there. But now partly because I'm so aware of my age (seventy-one), I see books as a problem I might end up imposing on my heirs.

My own manuscripts I sell to the Beinecke, and in the past I used to give them books that had helped me in my own work, but I have the feeling the librarians don't really want those research books anymore.

Do you listen to audiobooks? Do you prefer reading aloud or being read aloud to?

I've never listened to an audiobook (I don't own a car). I used to like reading my own work aloud to my long-suffering friends, and I still plague my poor partner, Michael Carroll, with my own prose.

How do you dispose of the books you don't want—donating, recycling, putting out on the curb? Do you have any taboo against throwing away books when

you're done reading them, or replacing books when they fall apart from wear and tear?

I have no taboos about getting rid of books. I try to be a good citizen and give them to Housing Works, but if I truly despise a book, I'll put it in the garbage. I don't have tapes or LPs anymore, but I do keep hundreds of CDs, though I'm trying to weed them, too.

Do you lend books to friends?

I'm always giving books I've read to friends if I think they'd like them. There are so many new titles and so few reliable ways to know which are the good ones that I suppose friendship networks—composed of friends you respect and trust—are the best way to locate a good book.

What do you imagine your library looking like five, ten, twenty years from now? Do you think you'll still own objects made of paper and glue? And—with apologies for a morbid question—do you ever think about what will happen to your library after your death?

Yes, I imagine that there will still be paper books and that I'll still be reading them (of course I still write fiction by hand). I'm sure that after my death my books will be scattered just like my clothes and furniture.

Top Ten Books
Edmund White

Leo Tolstoy
Anna Karenina

Penelope
Fitzgerald
The Blue Flower

Anton Chekhov
*The Collected
Stories*

Alan Hollinghurst
The Folding Star

Vladimir Nabokov
Lolita

Henry Green
Nothing

Jean Genet
*Our Lady
of the Flowers*

Marcel Proust
*Remembrance
of Things Past*

Christopher
Isherwood
A Single Man

Murasaki Shikibu
The Tale of Genji

ANTON CHEKHOV

STORIES

TRANSLATED BY
RICHARD PEVEAR AND LARISSA VOLOKHONSKY

WITH AN INTRODUCTION BY RICHARD PEVEAR

VLADIMIR NABOKOV

LOLITA

VOLUME I

olympia press

ALAN
HOLLINGHURST
AUTHOR OF THE LINE OF BEAUTY

THE FOLDING STAR

penelope fitzgerald
the blue flower

ANNA
KARENINA
WINNER OF THE PEN/BOOK-OF-THE-MONTH CLUB TRANSLATION PRIZE
TRANSLATED BY RICHARD PEVEAR AND LARISSA VOLOKHONSKY
LEO TOLSTOY
PENGUIN CLASSICS · DELUXE EDITION

NOTHING
HENRY GREEN

"Very light fingers are at work here creating a
comedy of manners of high style, and the
result is at once humorous, delicate, flippant,
ordered, and dramatically wise." —Kirkus

Jean
Genet
Our Lady
of the Flowers

Introduction by
Jean-Paul Sartre

Panther

REMEMBRANCE
OF THINGS PAST

The definitive French Pléiade edition
translated by C.K. Scott Moncrieff
and Terence Kilmartin

VOLUME I
SWANN'S WAY
WITHIN A BUDDING
GROVE

MARCEL
PROUST

CHRISTOPHER · ISHERWOOD
A SINGLE MAN

Penguin Classics

MURASAKI SHIKIBU
THE
Tale
of
Genji

Translated with an Introduction by
EDWARD G. SEIDENSTICKER

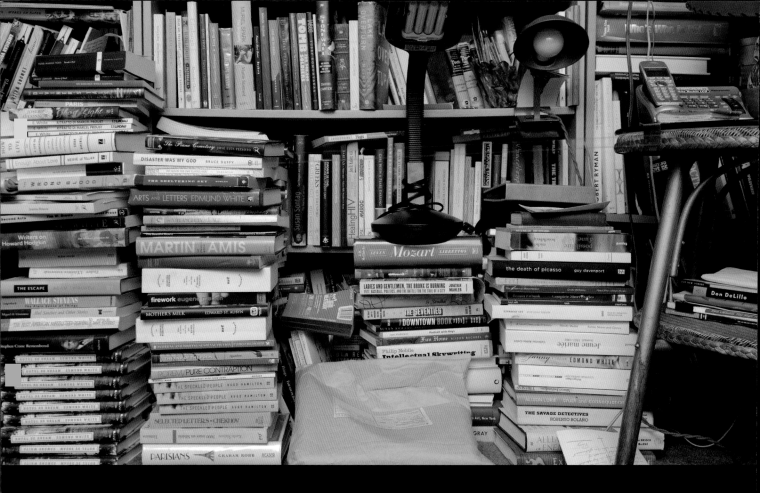

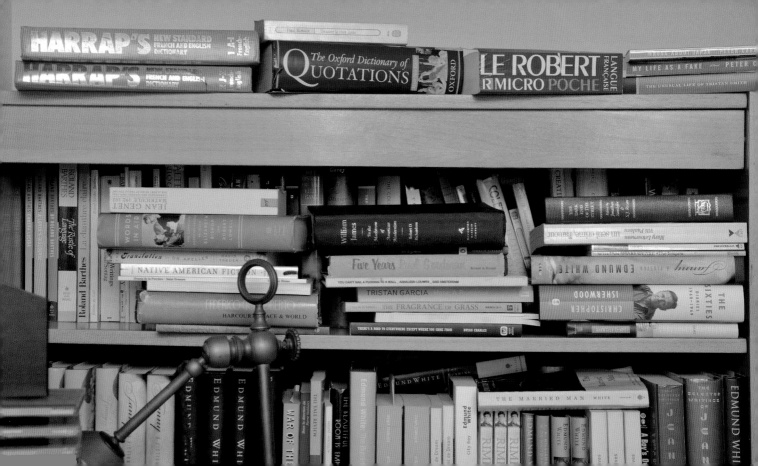

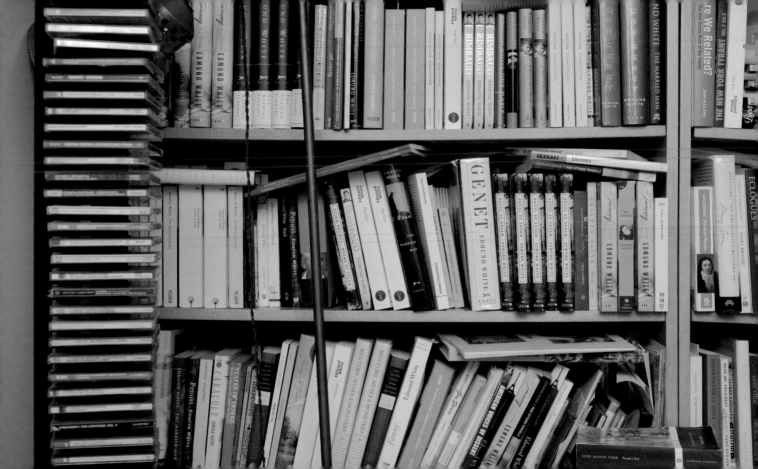

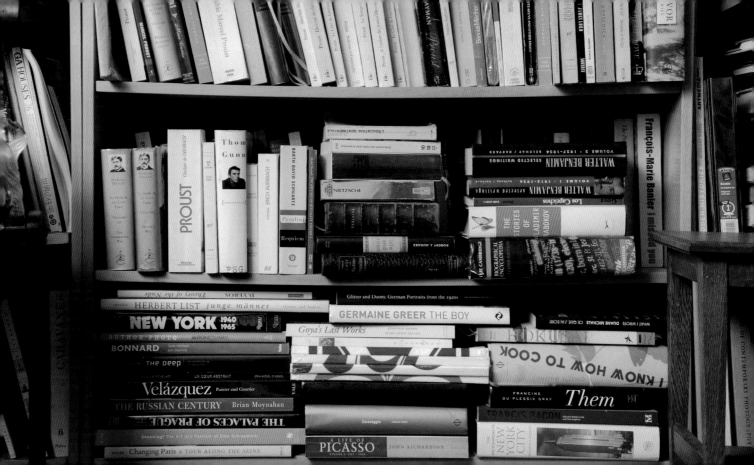

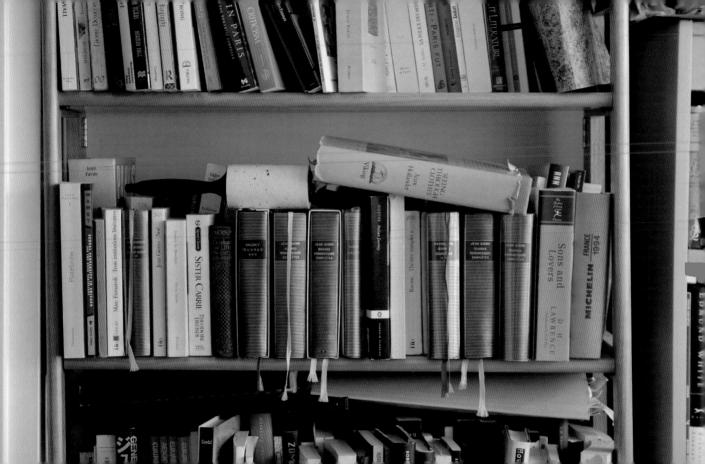

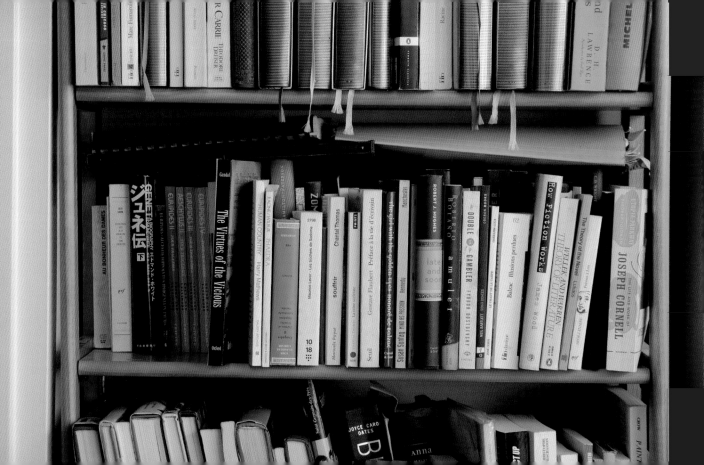

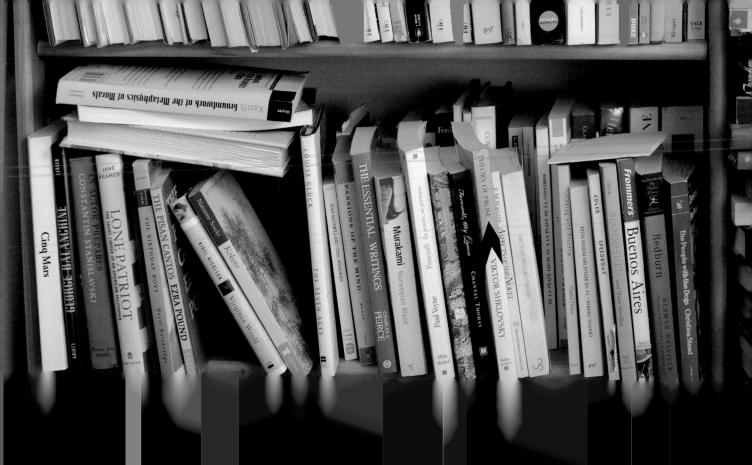

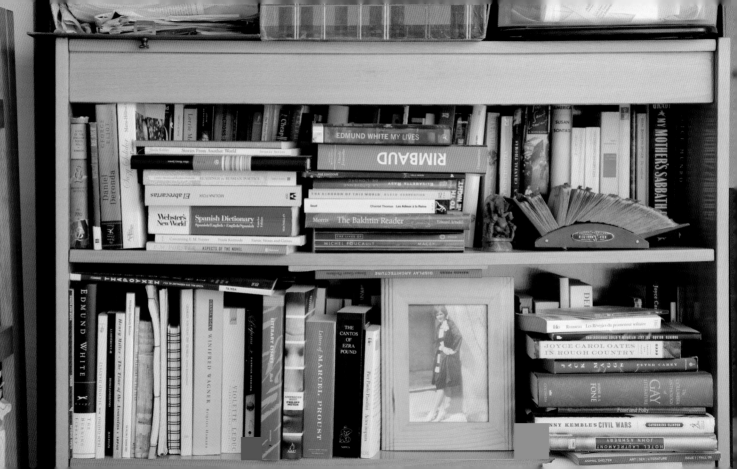

Contributors

Alison Bechdel is a cartoonist and author best known for her comic strip *Dykes to Watch Out For*, which ran from 1983 to 2008. In 2006 she published *Fun Home: A Family Tragicomic*, a critically acclaimed autobiography, which became a *New York Times* best-seller and was named one of *Time* magazine's Ten Best Books of the Year. She continues to illustrate for websites and magazines, including *Ms., Slate*, and the *Advocate*.

Stephen Carter is the William Nelson Cromwell Professor of Law at Yale, where he teaches courses on law and religion, the ethics of war, contracts, intellectual property, and professional responsibility. He has written numerous nonfiction books, and his first novel, *The Emperor of Ocean Park*, became a *New York Times* best-seller.

Junot Díaz received the 2008 Pulitzer Prize for Fiction for his novel *The Brief Wondrous Life of Oscar Wao*; his other books include *Drown* (1996). Díaz, who moved to New Jersey from the Dominican Republic in his early childhood, is professor of writing at Massachusetts Institute of Technology.

Rebecca Goldstein's books include *Properties of Light: A Novel of Love, Betrayal, and Quantum Physics, Incompleteness: The Proof and Paradox of Kurt Gödel*, and *Thirty-Six Arguments for the Existence of God: A Work of Fiction*. In 1996 she became a MacArthur Fellow.

Steven Pinker is Harvard College Professor and Johnstone Family Professor in the Department of Psychology at Harvard University. He is a frequent contributor to the *New York Times, Time*, and the *New Republic* on topics such as language and politics, the neural basis of consciousness, and the genetic enhancement of human beings. His books include *The Language Instinct, How the Mind Works, The Blank Slate*, and *The Stuff of Thought: Language as a Window into Human Nature*.

Lev Grossman is a book critic and technology writer for *Time* magazine. After the international acclaim of his novel *Codex*, he published his third novel, *The Magicians*, which quickly became a *New York Times* best-seller.

Sophie Gee is an assistant professor of English at Princeton, where she teaches courses on eighteenth-century poetry and novels and on the history of satire. Her first novel, *The Scandal of the Season*, was named one of the best books of 2007 by the *Washington Post* and the *Economist*. *Making Waste: Leftovers and the Eighteenth-Century Imagination* was published by Princeton University Press in 2010.

Jonathan Lethem is a novelist and short story writer who has contributed to *Rolling Stone*, the *New Yorker*, and *Harper's*, among other publications. His 1999 novel *Motherless Brooklyn* won the National Book Critics Circle Award for Fiction, and in 2003 *The Fortress of Solitude* became a *New York Times* best-seller. In 2005 Lethem received a MacArthur Fellowship.

Claire Messud is writer in residence at Tulane University. Her first novel, *When the World Was Steady*, and her collection of novellas, *The Hunters*, were both finalists for the PEN/Faulkner Award. Her most recent novel, *The Emperor's Children*, was named one of the Ten Best Books of the Year for 2006 by the *New York Times Book Review*.

James Wood is a literary critic and novelist. He is currently Professor of the Practice of Literary Criticism at Harvard University and a staff critic at the *New Yorker*. He is the author of three books of criticism and an autobiographical novel, *The Book Against God* (2003).

Leah Price is professor of English at Harvard University. Her books include *The Anthology and the Rise of the Novel* (2000) and *How to Do Things with Books in Victorian Britain* (2012).

Philip Pullman is the author of nearly twenty books, his most well-known work being the trilogy *His Dark Materials*. The second of these books, *The Amber Spyglass*, was the first children's book to win the Whitbread Book of the Year Award, and his other books have garnered accolades including the Carnegie Medal and the Guardian Children's Book Award.

Gary Shteyngart is the author of three novels and is a frequent contributor to such publications as the *New Yorker, Slate,* and the *New York Times*. His first novel, *The Russian Debutante's Handbook,* won the Stephen Crane Award for First Fiction, the Book-of-the-Month Club First Fiction Award, and the National Jewish Book Award for Fiction.

Edmund White's works include novels, autobiographical sketches, and social commentary, specifically focusing on gay identity in America and the effects of AIDS on society. A member of the American Academy of Arts and Letters and of the American Academy of Arts and Sciences, White is best known for his biography of the French writer Jean Genet, which won the National Book Critics Circle Award in 1994.